INTERPRETIVE PLANNING FOR MUSEUMS

INTERPRETIVE PLANNING FOR MUSEUMS

Integrating Visitor Perspectives in Decision Making

Marcella Wells, Barbara Butler,
and Judith Koke

Routledge
Taylor & Francis Group
LONDON AND NEW YORK

First published in 2013 by Left Coast Press, Inc.

Published 2016 by Routledge
2 Park Square, Milton Park, Abingdon, Oxon OX14 4RN
711 Third Avenue, New York, NY 10017, USA

Routledge is an imprint of the Taylor & Francis Group, an informa business.

Library of Congress Cataloging-in-Publication Data:

Wells, Marcella D, 1953-
Interpretive planning for museums : integrating visitor perspectives in decision making / Marcella Wells, Barbara Butler, and Judith Koke.
 pages cm
Includes bibliographical references and index.
ISBN 978-1-61132-156-2 (hardback : alkaline paper) — ISBN 978-1-61132-157-9 (paperback) — ISBN 978-1-61132-158-6 (institutional eBook) — ISBN 978-1-61132-673-4 (consumer eBook)
1. Museums—Planning—Decision making. 2. Interpretation of cultural and natural resources—Planning—Decision making. 3. Museum visitors—Attitudes. 4. Museums—Social aspects. 5. Museums—Educational aspects. I. Butler, Barbara H. II. Koke, Judith, 1958- III. Title.
 AM121.W45 2012
 069—dc23
 2012035359

ISBN 978-1-61132-157-9 paperback
ISBN 978-1-61132-156-2 hardback

CONTENTS

List of Figures

LIST OF TABLES

PREFACE

This book started on a cocktail napkin. Following our 2001 workshop called Understanding Visitors—The How and Why of Visitor Research,[1] two of us, Barbara and Marcella, met for happy hour, and The Triangle was conceived over drinks. This triangle developed into our Outcomes Hierarchy: a model that arrays visitor experience outcomes in progressive tiers of a triangle and is designed to help museum practitioners plan, and consider the effects of, their interpretive efforts. In 2002, we published the hierarchy as the Visitor-Centered Evaluation Hierarchy in an article in *Visitor Studies Today!* (Wells and Butler 2002); a second article, in which we revised the hierarchy slightly, appeared in *The Public Garden* (Wells and Butler 2004). No fewer than a dozen revisions and refinements later, the Outcomes Hierarchy serves as the centerpiece of this book. In our discussion here, however, we take the hierarchy a step further by exploring its usefulness for integrating visitor perspectives in interpretive planning for museums.

Often visitor research and interpretive planning are pursued independently of one another. On the one hand, visitor studies specialists are interested in how their evaluation results will be used to achieve more effective visitor experiences. On the other hand, educators and interpretive planners are interested in, but are sometimes uncertain about, how to pursue or apply visitor studies. Our discussion and recommendations are intended to help informal learning institutions integrate visitor perspectives into interpretive planning by drawing strongly on the Outcomes Hierarchy. We hope that readers will hold the hierarchy in their minds as they encounter crucial moments of decision throughout the process of planning visitor experiences. Although this book is not specifically about evaluation, it aims to ensure that visitor perspectives are considered throughout planning. Our emphasis on the importance of integrating visitor perspectives into the practice of interpretive planning is based on the belief that the greater our understanding and use of visitor perspectives and input, the more likely we are to develop and realize relevant and engaging programs and exhibitions.

We three authors all are fortunate to have had careers that span multiple disciplines that, in turn, support an integrated approach to visitor experience planning. We have spent our professional lives questioning: What can we learn from visitors and our communities that will help us

11

develop a successful project and document our success? How do desired outcomes help shape a project? How do we decide what to eliminate in tight budget or schedule situations? We advocate for thoughtful and intentional interpretive planning that integrates visitor perspectives, believing that this approach is the next step in working with, rather than for, our communities, a step toward becoming truly visitor-centered and effective as essential learning institutions of the twenty-first century.

Examples of interpretive plans in museums are somewhat rare at present. We hope that this book will ignite enthusiasm for planning and stimulate increased interest and practice in a more integrated approach to planning visitor experiences. We would like this to be the beginning of a dialogue with our colleagues, and so we welcome contact, critique, and discussion. Perhaps a revised edition will shortly be required as this dialogue continues.

Sincere thanks go to our reviewers, Daryl Fischer, Charlie Walter, and Kelly McKinley, for providing valuable feedback on drafts of this book. Their perspectives on our perspectives proved immensely helpful in clarifying our ideas. Second, we would like to thank our graphic artists, Sue Sell and Michelle Cerise, and illustrator Mickey Schilling for their parts in creating images that aid readers in visualizing our ideas. Third, we want to thank the institutions that granted us permission to use excerpts from their interpretive plans as examples in the latter chapters of the book and Appendix B. Finally, we thank our respective husbands, Alan and the two Glenns, for their patience and encouragement throughout the book's genesis.

Chapter 1

Introduction

1.1. TRUE STORY: DEVELOPING WITHOUT A PLAN

A well-established, successful, midsize history museum begins a process for mounting a new permanent exhibition. Having received a planning grant from a national foundation, the curatorial and education staff meet to begin "planning"—in this case, beginning with a topic, a list of possible objects and photos from the collections, and a brief content outline.

As the staff continues to develop the objects list and content outline, planners contract with a local exhibit design firm to develop schematic ideas and eventual design drawings. Some weeks later they hire an evaluator to conduct an evaluation of exhibit concepts and possible interactive elements. A few months later they submit a planning grant report to the foundation containing a theme document, design drawings, object lists, final label copy, and the evaluation report.

This scenario is all too familiar in some museums and informal learning settings: exhibit ideas are spawned, often prompted by the collections, and the development process begins. A grant proposal is submitted, funding is secured, and artifact selection, content development, and design development begin. Depending on the institution or the situation, sometimes an outside contractor (e.g., exhibit designer, evaluator, content specialist) is brought into the process. An exhibition is installed leaving many decisions undocumented and often leaving fundamental questions unanswered. Questions such as why the exhibition is important, who are the intended audiences, and what are desired visitor outcomes may be addressed in a grant application, but too often responses to these questions are not clearly articulated and made transparent to stakeholders of the project including museum staff, contractors, institution partners, and other funders.

Wells, Marcella, Barbara Butler, and Judith Koke. "Introduction." In *Interpretive Planning for Museums: Integrating Visitor Perspectives in Decision Making*, 13–23. ©2013 Left Coast Press, Inc. All rights reserved.

The impetus for a new exhibit or interpretive project can come from any of a number of sources—donors, board members, museum staff, a community leader, or a "friend" of the institution. For example:

- Has a new CEO or board president, passionate about a favorite topic, ever directed the staff of your institution to develop a new exhibit on that topic?
- Has one of your staff rediscovered a fascinating object in the collection and approached the director about wanting to develop an exhibit on that object or that part of the collection?
- Has a wealthy patron offered a gift with the stipulation that the museum should develop an exhibition about that topic?
- Has a donor wanted to control the content of the exhibit because he or she holds the purse strings?

Despite the reality of these and similar situations, we contend that planners need to consider, from the start, questions such as: Why do this project at this time? How does this exhibit fit within the mission of the institution (or within the vision for the institution in the community or in society at large)? What community need would it fill? Who are the audiences and what do they know or care about the proposed topic? What role does the institution want the exhibit to play in public understanding of, or engagement with, the topic? What resources, issues, and ideas led up to the decision to go ahead with the exhibition? What do we want this exhibit to be about—in general and specifically? Who is the team that will to work on this project? How should the process of realizing this exhibit be organized? Who will coordinate or manage the process?

This book is about deliberate and systematic planning for visitor experiences—interpretive planning. We define interpretive planning, underscoring the importance of integrating visitor perspectives and input into that planning as well as the need to be systematic and logical in decision making as it relates to visitor experiences in and with museums. We advocate critical thinking, deliberation, and collaboration. At the same time, the approaches we present take into account the need for institutions to remain nimble, honoring the need for flexibility in decision making. Although we describe processes, we also recognize that, depending on an institution's mission, size, location, audience, and community, the ability to adapt the processes to idiosyncratic situations and needs is essential.

1.2. THE NEED FOR THIS BOOK

Issue 1. Arbitrary Decision Making

Traditionally, museums have been object-centered institutions, and thus it is not unusual for the genesis of an exhibit to come from a director, donor, funder, individual staff member, or political leader who has an affinity for a particular idea, topic, or object. This situation can result in decision making that is arbitrary, inefficient, ineffective, or unsustainable.

In our opening story, the institution was compelled by a particular topic and a set of objects. They probably had a well-intentioned and reasoned audience-based purpose, but if conversations about that purpose did take place, the institution did not formally document their thinking about visitor perspectives or other related factors that shaped their decisions. If deliberations did indeed take place prior to launching into the exhibit development process, the logic and written record of those deliberations were not apparent. A written record may not immediately seem important to the institution's staff, but through the life of the project the implications of decisions may affect numerous stakeholders, including board members, funders, educators, designers, evaluators, community leaders or partners, and contractors, and writing them down will add considerably to accountability and transparency. Money and time are wasted and professionalism is threatened if any of these stakeholders has to probe the institution to address rationale, outcomes, target audiences, or other impact-related issues. In this book we present recommended processes for discussing and recording intentional and thoughtful decisions related to visitor experiences with museums.

Issue 2. Government Performance and Results Act (GPRA)

In 1993 the U.S. Congress passed the Government Performance and Results Act (GPRA), legislation that refocused the attention of federal funding agencies to accountability and outcomes. Gradually, throughout the 1990s, the trickle-down effect of this legislation began to be felt in museums, initially resulting in new expectations for federally funded projects but also affecting how museums thought about, tracked, and demonstrated success. Consequently, federal funding agencies, including the National Science Foundation (NSF), Institute of Museums and Library Services (IMLS), and the National Endowments for the Arts (NEA) and Humanities (NEH), began mandating that informal learning grants address outcomes for all informal learning initiatives.

Around the same time, during the 1980s and 1990s, the growing field of visitor studies was focusing its attention on all things visitor:

understanding who visitors are (demographically and psychographically); exploring visitor conceptions, misconceptions, and perspectives related to exhibit topics; and researching visitor needs and the outcomes of visitor experiences. Some of these efforts, particularly front-end evaluations, targeted what we can learn about visitors before their museum visit. Other visitor studies (formative evaluation efforts in particular) target what we can learn about visitor perspectives during exhibit design and development processes. Still other visitor studies efforts (i.e., summative evaluation) target what visitors take away from their experiences in museums or how they are changed or transformed by those experiences. Although the passage of GPRA catalyzed visitor studies by spotlighting outcomes and impact, the ideas related more broadly to visitor perspectives have been slow to make their way into the lifeblood of museums.

Issue 3. Leisure Time and Choice

Chubb and Chubb, in their book *One Third of Our Time?* (1981), embraced the notion that, in the United States, one-third of people's time is discretionary, and some of that time is likely to be spent on leisure pursuits. However, according to Juliet Schor, in the past several decades leisure time has become a "conspicuous casualty of prosperity" (1991, 2). Schor's leisure research documents a gradual but steady rise in the amount of time Americans spend at their jobs, and, because the total time spent per day at work is now greater than it was in the 1940s, time for leisure pursuits has diminished. At the same time, and for a variety of reasons, not the least of which is technology (e.g., social media, gaming), people today have a much larger array of leisure choices than ever before.

Indeed, leisure choice is complex. A full discussion of that topic is beyond the scope of this book, but it is germane here to recognize that, afforded precious little time for leisure, people desire different things at different times to fulfill different leisure needs. As Marcella and her colleague Ross Loomis (Wells and Loomis 1998) offer, museum opportunities involve multiple and concurrent choices related to activity (museumgoing versus other possible activities), setting (e.g., science center, history museum, art museum), experience preferences (e.g., be with friends and family, explore, have fun, be active), and perceived benefits (e.g., skill enhancement, family solidarity). Collectively, museums compete with sporting events, outdoor recreation, shopping, travel, movies, and technology to gain a foothold in people's leisure time. Without doubt, museums are among Americans' leisure opportunities, but they are only one of myriad (and increasingly diverse) leisure choices that

people make daily. Given this competitive context, the need for deliberate and systematic planning and decision making in museums is significant.

Issue 4. Changing Paradigm of Education

The nature of education and learning is changing. As Kratz and Merritt suggest, "the U.S. education system is on the cusp of transformational change" (2011, 188). These authors discuss how growing dissatisfaction with the formal education system and the proliferation of nontraditional forms of education are destabilizing current education structures in the country. Sir Ken Robinson (2008) describes this destabilizing a bit differently by saying that our traditional education system—a system rooted in the intellectual culture of the Enlightenment and the economic circumstances of the Industrial Revolution—still resembles the factories of that revolution, with students moved along assembly lines of learning in batches of same-age cohorts. He argues that, despite significant cultural and societal changes (e.g., technology, changing demographics, and social reform attempts), the current education system is trying to meet the future by doing what has been done in the past. He argues that rather than anesthetizing learners using the traditional factory model we should be waking them up by stimulating their imaginations and creativity. The concept of structuring learning by way of thinking (e.g., critical thinking, decision making, moral reasoning, judgment, leadership) is not new. Tagged "21st Century Skills," these ideas are embraced in some charter schools; lab schools; science, technology, engineering, and math (STEM) schools; and even by some homeschoolers. Museum and museum education program planners also are beginning to focus on these skills.

The torch of educational reform is being carried by others as well. KnowledgeWorks, a think tank associated with the Institute for the Future, presents a context for thinking about the future of learning that is not limited to K–12 education (KnowledgeWorks 2008). These thinkers acknowledge several economic, societal, organizational, systemic, and personal trends that foreshadow a significant transformation in education in the United States—a transformation that includes, among other things, contested authorities, diversified learning geographies, personalized learning philosophies, and a global learning economy.

The groundswell of concern about public education and reform in recent decades may actually portend a significant transformation in education and learning on a broader scale. The Learning Landscape that we present here in graphic form in Figure 1.1 reflects some of the speculations by educators, sociologists, futurists, and others concerned with the challenge of literacy in the new millennium.

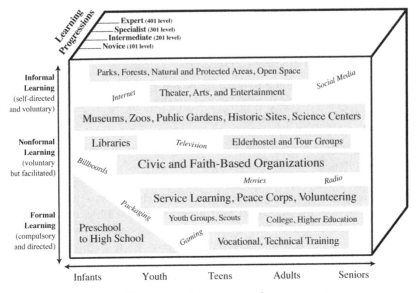

Figure 1.1 Learning Landscape

First, our Learning Landscape suggests that lines are increasingly blurred between *formal* learning, which is mostly extrinsically motivated and facilitated (e.g., K–12 public education), and other types of learning termed *nonformal* learning, which is intrinsically motivated but still facilitated (such as Boy Scouts, Elderhostel), and *informal* learning, which is intrinsically motivated and self-directed (such as visits to museums, libraries, and parks). Second, the Learning Landscape captures the concept of lifelong learning and how needs, interests, and desires for leisure (and learning) may change across an individual's life course as influenced by work, family, aging, and many other factors. Third, the Learning Landscape suggests learning progressions related to topics or subjects that are not necessarily tied to life course. For example, a PhD in physics, dedicated in life course to expert knowledge in that area, might visit a museum exhibit about the Civil War while on vacation and expand a novice knowledge of that topic based on an occasional hobby of collecting military paraphernalia.

Finally, the Learning Landscape arrays multiple opportunities for learning across time and space. The opportunities shown are neither exhaustive nor mutually exclusive; rather, the array within the three axes suggests a vast set of possible choices that involve engagement and learning. The Learning Landscape shows that, as learning and education take on new meaning in the near future, opportunities for museums to make a significant

contribution to learning in the United States (and ultimately to national literacy) have never been greater (National Research Council 2009).

Issue 5. Shrinking Dollars

Difficult economic times, shrinking government funding, evaporating interest earnings, and in some cases decreasing philanthropic donations are increasingly forcing museums to make tough decisions about allocating resources and setting priorities. A 2008 report from the Institute of Museum and Library Services (IMLS) indicates that while sources of income in the museum sector are diverse, governmental monetary support to non-government-administrated museums is significant, ranging from 7 to 24 percent, depending on the content area. This makes museums particularly vulnerable to political shifts. A 2010 American Association of Museums publication stated that "more than two-thirds (67.1%) of museums in the survey reported at least moderate financial stress in 2009" (Katz 2010, 2). In this same publication, half of museums reported a decline in total revenue, and nearly 45 percent reported a decrease in both government support and private corporation donations. As if this were not bad enough, investment income took the hardest hit that year, with over 60 percent of museums reporting a decline (Katz 2010, 9).

In the United Kingdom, museums are experiencing significant operational shifts in response to decreasing government funding, with many cutting staff, reducing hours, and adjusting programs, all the while experimenting with new sources of income (Newman and Tourle 2011). While the economic situation varies broadly by region, tightening budgets and economic uncertainty underscore the importance of leveraging current resources to maximize impact, setting clear priorities, and addressing the importance of defining and measuring public value.

To summarize, in this book we first acknowledge the need for more deliberate decision making that embraces deeper, more analytical thinking among museum professionals. Second, we are compelled to restate and reinforce the notions put forth by GPRA related to accountability and outcomes: understanding accountability and outcomes can help institutions plan exhibits and provide learning programs that will better achieve intended impacts. Third, we recognize the complexities facing all of us when making tough decisions about allocating precious leisure choices. Fourth, we also appreciate that the effects of transformations in education and learning may still be uncertain, but change is nonetheless impending, and there is thus a need—a somewhat urgent need—for museums to position themselves directly in the midst of a learning landscape for the new millennium. And finally, although funding is tight and funding agencies increasingly insist

on accountability and transparency, staking a strong and central evidence-based claim about the important public value of museums is important for their long-term viability and economic sustainability.

1.3. The Purpose of This Book

The purpose of this book is to change how museums think about planning visitor experiences. As noted by Trautmann (2011, 1):

> Museums are realizing that they serve their community best when, rather than serving as an isolated entity that supplies exhibitions, programs and other educational experiences, they instead become a partner in their community's aspirations, issues, and solutions. Because communities, like people, support what they perceive as necessary, a key question for [museums] is: how best can they become more essential in their community, deliver maximum impact, receive appropriate recognition, and grow the support needed to do their good work?

In recent years, museums have made great strides in becoming more engaged as active partners with their communities, thus helping to create collaborative opportunities and stimulate civic pride. The more closely museums consider and engage visitor perspectives in the development of new offerings, the more "necessary" their communities are likely to consider them.

Traditionally, most museums acknowledge they exist to preserve and manage the cultural, natural, and scientific legacy of humans as manifest in their collections and programming. Gradually, however, institutions are increasingly recognizing that they exist to serve the public—a role described as a "social enterprise" by Stephen Weil (2002, 7). Many museums have processes they activate to prepare new exhibits or renovate older exhibits; these procedures may be referred to as exhibit development, design development, concept planning, or exhibit planning, and they can vary widely depending on the size and nature of the institution. The move toward serving the public, however, includes the development—thus far by only a small number of museums—of institution-wide interpretive plans that describe strategic goals and desired outcomes for visitor experiences. In addition, since the mid-twentieth century, visitor studies and evaluation practice have increasingly gained acceptance as constituting a discipline and professional practice. Some museums know about or engage in evaluation, although many do so more as a funding requirement than a planning aid, but some museums still know little or nothing about visitor studies and evaluation. New understanding of how to study visitors and how to make meaning in museums is forcing the

field to become more inclusive of visitor perspectives when planning for visitor experiences.

Thus, our purpose for writing this book is threefold:

- to elaborate a process for planning and decision making related to visitor experiences in museums,
- to highlight the notion of outcomes and impacts as they relate to visitor experiences in museums, and
- to describe and encourage the integration of visitor perspectives (and outcomes thinking) in planning and decision making for museums.

Our discussion is deliberately organized to meet the needs of professionals in various roles in today's museums. In Chapter 2 we provide contextual material about museums as learning institutions; about visitors and how thinking about them has changed over time; and about learning, visitor experiences, and planning for visitor experiences. In Chapter 3 we define interpretive planning and expand on several related notions by proposing a process for integrating visitor perspectives into the practice of creating exemplary visitor experiences. In Chapter 4 we address outcomes and impacts as core concepts of visitor perspectives and introduce our Outcomes Hierarchy as a conceptual framework for organizing thinking about audiences, outputs, outcomes, and impacts. In this chapter, we describe the tiered hierarchy in detail and provide guidance for developing desired outcomes. We refer to the various elements of the hierarchy throughout the book, but in Chapters 5 and 6 specifically we include small triangle icons, signifying the hierarchy, to draw attention to the numerous points where integrating visitor perspectives is most appropriate.

Based on the ideas presented in Chapters 3 and 4, we discuss in detail specific planning considerations and suggestions for integrating visitor perspectives in two different scales of interpretive planning: master interpretive planning (Chapter 5) and project interpretive planning (Chapter 6). These two chapters also present several concrete examples illustrating various aspects of and approaches to interpretive planning. Chapter 7 concludes the book with a review of how this approach to planning may alleviate some ongoing difficulties, as well as contribute to the larger, fieldwide conversation about the public value of museums.

Our hope is that material provided here about integrating visitor perspectives and outcomes into interpretive planning will help museums to:

- initiate planning discussions and begin a written record of decisions prior to design development processes;
- more thoroughly address audience analysis for planning learning experiences and decision making related to these experiences;

- move from thinking solely about outputs (numbers) as a measure of success to thinking more about outcomes and impacts when describing and evaluating the effects of museum experiences; and
- consider their role as active and central players in a community or the social context of national learning and literacy, and thus work toward identifying and deliberately planning for appropriate outcomes and impacts.

To help organize and clarify terms, we have inserted several *term clouds* in locations where we feel there may be confusion about related expressions. Each term cloud contains several words that are often used to have the same or similar meanings. In each, the bold term is the one we have selected to use as consistently as possible. We endeavor to discuss these core concepts thoroughly, but we do not debate the subtle distinctions between the various terms within each cloud. Rather, we hope that presenting terms in this way will stimulate discussion among readers, and that practitioners will deliberate about how terms are best used in their unique situations. Readers may take issue with the fact that some terms presented may not be exactly synonymous; however, as there is little documented consensus about definitions or usage of some of these terms, we present the term clouds to suggest how we think these confusing terms and concepts group themselves. In addition, a glossary is provided for other terms and concepts used in the book.

1.4. AUDIENCES FOR THIS BOOK

This book is addressed to museum professionals of all stripes. First, it is for directors and CEOs who daily face decisions about institutional viability and impact. Such readers might find Chapters 1, 2, 3, and possibly 5 most useful. Second, it is for educators and interpreters who find themselves on the front line in face-to-face contact with audiences and who spend their day in situations of teaching, exploring, inquiring, discovering, and learning with visitors. We hope these readers find the entire book useful not only for professional practice (Chapters 3, 4, 5, and 6) but also for context and leverage (all other chapters). Third, this book is for interpretive planners and exhibit developers who are the creative and practical power behind visitor experiences and who help set the course for deliberate and intentional decision making, accountability, and ultimate impact. We expect that Chapters 2, 3, and 4 will be

especially useful for these readers and also that Chapters 5 and 6 will offer new insights for helping buttress interpretive planning and exhibit development decisions. Fourth, this book is for evaluators and visitor studies professionals, who continually strive to integrate visitor perspectives in all levels of museum decision making. Although this is not an evaluation text, we hope that Chapters 3, 4, 5, and 6 are useful to professionals involved in evaluation practice. Finally, we expect that the entire book will be useful for museum studies students (and their teachers) as an overview of interpretive planning and visitor experiences, giving them an understanding of the bigger picture so that they are then better able to choose their roles within that context.

Chapter 2

Conceptual Foundations

2.1. Museums as Learning Institutions

The word *education* for some, and particularly for many in museums, implies public schools or K–12 education. The word *learning* however, typically suggests a broader construct. As described in Chapter 1, the learning landscape (see Figure 1.1) includes many sectors of society and assumes learning by all citizens at several points across time, space, and ability. In other words, schools are not the only places of learning. In fact, many argue that the central foothold schools have had in society for the last century may be slipping (KnowledgeWorks 2008; Kratz and Merritt 2011; Robinson 2008). Access to information and opinions on demand through the Internet is changing how and when we learn. Underperformance by schools in general and by some teachers and students in particular is commonly noted. Although a thorough discussion of efforts to reform the U.S. school system is beyond the scope of this book, it is important to note that some reform strategies recognize the need for engaged and supportive communities in building systemwide capacity for U.S. schools (U.S. Department of Education 2011). This presents an open door for museums to position themselves as essential centers of learning.

Museum

Informal Learning Institution, Zoo, Arboretum, Nature Center, Visitor Center, Park, Science or Nature Center, Art Museum, Historic House or History Center, Children's Museum

To a large degree, museums[2] are entrusted with the soul of a nation; museum collections are its heritage. They represent the history and culture; the advancements in science, technology, medicine, and engineering; the artistic and creative heritage of a community, region, or country. And yet, museums

are underutilized as a community asset for education. Ultimately, literacy depends a great deal on informal learning opportunities for all the populace. This is true for any community or country, but in the United States it includes opportunities in this nation's nearly 20,000 museums.[3] Toward this end, the American Association of Museums (AAM, renamed the American Alliance of Museums in September 2012) published *Excellence and Equity*, which "points the way for museums to expand their role as educational institutions" (AAM 2008a, 2). Though the original publication (1992) was intended as a catalyst for embracing culturally diverse audiences, revisions of *Excellence and Equity* have aimed to solidify broader notions: that education is central to the mission of museums, that museums must reflect our pluralistic society, and that leadership is key to fulfilling a public service role. In addition, AAM's Museum Assessment Program (MAP), a cooperative agreement with the Institute of Museums and Library Services (IMLS), provides self-improvement opportunities for museums to assess capabilities within a context of national standards and best practices (2008b). Many other professional organizations, such as the American Zoo Association (AZA), Association of Science-Technology Centers (ASTC), Association of Children's Museums (ACM), American Association for State and Local History (AASLH), Association of Art Museum Directors (AAMD), American Public Garden Association (APGA), share in the ideal that learning in our community parks, zoos, gardens, galleries, and historic sites contributes to national learning and literacy. All of these organizations acknowledge that building strong, systemwide capabilities among museums is necessary not only for preserving our national heritage and culture, but also for having a systemic effect on learning in this country.

We assert that deliberate and systematic interpretive planning is essential if museums are to realize their full potential as learning institutions. Fundamentally, public understanding of science, technology, culture, history, humanities, and other topics is crucial for the success of a democratic society (Dewey 1916). And if we believe, as Dewey suggests, that a democracy is only as strong and successful as the individuals within it, and that successful individuals are well-informed individuals, then education is part of our democratic responsibility. As museums offer opportunities for individuals of all ages and experiences to construct new understanding and knowledge, they also work to integrate current learning theory into their practice. Hence, museums have evolved from institutions that focus on transmitting information to environments that support learning. This requires parallel attention to where and how visitors start their learning journey, what they bring to these experiences, and what meaning they make in those experiences. For an in-depth review of Dewey's philosophy and

how it relates specifically to the importance of museums in helping advance a democratic society, see George Hein's *Progressive Museum Practice* (2012).

2.2. How We Have Come to Understand Visitors

Educators, evaluators, and psychologists had long been fascinated with various aspects of learning in museums before there were visitor studies professionals. Themes such as the role of museums in society, learning in museums, and visitor behavior have been discussed in the literature, although for the most part, until recently, these themes had been individual voices rather than a fieldwide conversation.

In 1889, for example, G. Brown Goode gave a lecture at the Brooklyn Institute about "The Museum and the Future." Goode was the Smithsonian's earliest proponent of museums as educational institutions, promoting the role of education, formally or casually, for the visiting public, and he compared the societal and cultural roles of museums to those of libraries—a theme that is still familiar today. Forty years later, in 1917, John Cotton Dana, director of the Newark Museum, published a series of four books collectively known as *The New Museum Series*. In the first of these he argued for a user-centered museum, a museum based on ideas, that attracts the blue collar worker "as much [as it attracts] the professional man and the man of leisure" (quoted in Butler 1988, 2). He recognized a broad education system that transcended the formal schoolhouse and stressed collaborations between museums, libraries, and public schools.

One of the earliest published visitor studies was conducted by the Yale psychologist Edward Robinson (1928). He conducted carefully controlled studies in several museums, studying museum fatigue and "picture viewing time" with variables that included physical fatigue, picture size, location on a wall, and density.[4] He found that mental fatigue trumped physical fatigue. Robinson offered a challenge:

> The behavior of the museum visitor offers an inexhaustible stock of problems. There is no reason, therefore, to try to state how the finishing touches might be put upon the type of work that we have begun. The question is not one of how to finish the job, but simply one of how it may more profitably be continued and extended. (Robinson 1928, 66)

In 1940, Carlos E. Cummings, director of the Buffalo Museum of Science, published *East Is East, West Is West* in which he compared museums to world's fairs. In his first chapter, "The Problem of the Visitor: An Analysis of the Visitor and of Exhibits," he addressed

the visitor experience. He mentioned several visitor-related issues that have a contemporary ring, including visitor entry narratives (the unique storehouse of personal experiences, memories, and knowledge with which the visitor enters), naive notions, and how to judge success. Particularly insightful for 1940 was the observation that "The museum can count its visitors, can discover any number of coefficients and statistics relating to the time spent by individuals in the museum or before selected exhibits, but it is very much to be doubted whether the ordinary stop-watch statistics based on the time factor alone have any real value in determining education effectiveness." He then opined, "Without some more intimate method of approach, we can hardly go much further than to take the position that if our callers consistently spend a large part of their time in one room or in studying a single exhibit, we can feel they are truly interested in it and that it is accomplishing, to a degree at least, its ultimate destiny as ordained" (Cummings 1940, 14).

In 1942, Theodore Low, then a graduate student of art history and adult education at Columbia University, wrote in *The Museum as a Social Instrument* that "the purpose and the only purpose of museums is education in all its varied aspects from the most scholarly research to the simple arousing of curiosity. That education, however, must be active, not passive and it must always be intimately connected with the life of people" (Low 1942, 21). A number of years later, Edward Alexander presented a brief history of audience research in *Museum in Motion: An Introduction to the History and Function of Museums*. He told his museum studies students, "The museum needs to consider the psychological, sociological, and motivational aspects of its permissive and informal educational efforts and to fashion research methods that will test and improve their effectiveness" (Alexander 1979, 165). Otherwise, as Stephan de Borhegyi observed, "museums will fail in their function to provide mass education and will become simply glorified warehouses, recreation facilities, and exclusive clubs for the learned" (de Borhegyi 1965, 91).

Over the next decades, individual studies on various aspects of visitor behavior, ranging from explorations of wayfinding and museum fatigue to label length and cognitive attention, continued to accumulate until the inaugural issue of *Visitor Behavior* was published in 1986. This publication became the first professional journal for the visitor studies field. Two other publications followed shortly thereafter: *ILVS Review: A Journal of Visitor Behavior*,[5] published from 1988 to 1992, and *Current Trends in Visitor Research*, an occasional publication of AAM's Committee on Audience Research and Evaluation. In 1988, the Visitor Studies Association was founded.

This professional organization, with its annual conference and journal, *Visitor Behavior*, brought together academics and practitioners interested in visitor experiences. Also by the late 1980s, some museums were conducting summative evaluations of their exhibitions. As the visitor studies profession grew, other forms of evaluation—such as front-end, formative, remedial, and critical appraisal—became more fully developed and defined. Over time, professionals in visitor studies and evaluation have shared their expertise with museum professionals, in both practice and publications.

In the late 1980s and early 1990s, visitor studies largely focused on how exhibitions worked. After spending significant amounts of time and money building exhibitions, some of which remained in place for decades, exhibition designers and educators wanted to understand whether visitors were using them as intended and were receiving carefully crafted messages as hoped. This research largely employed tracking and timing studies, usually in combination with exit surveys (e.g., Serrell 1998), and focused primarily on whether or not an exhibition had communicated its intended messages.

The passage of the Government Performance and Results Act (GPRA) in 1993 brought attention to accountability and, consequently, to outcomes. This has moved some of the focus of summative evaluation from measuring visitor response to an exhibit to understanding instead the change in the visitor as a result of participation. Furthermore, with the change in understanding of how visitors make meaning in informal learning settings, Hein's *Learning in the Museum* (1998) encouraged readers to ask how visitor research could be used to facilitate meaningful learning experiences in museums. Clearly the seeds of visitor engagement and outcome evaluation were sown. Yet in 2008, Shettel, in his opinion piece "No Visitor Left Behind," still felt the need to reinforce the importance of a public-oriented and visitor-centered perspective by including evaluation and measures of outcomes in exhibit development.

Under the influence of a changing pedagogy in formal education, museums have begun to understand learning differently. They have moved away from a traditional behaviorist paradigm in which an expert teacher or museum educator identifies what needs to be learned and then transmits that information to the learner, with the learning being measured largely by the learner's ability to repeat and sometimes apply their acquired knowledge. As our understanding of how learning happens has changed, the concept of visitor perspective has begun to shift from visitors as recipients of expert ideas and information to visitors as participants in the construction of their own understandings. This change has required not only an increased attention to what constitutes effective interpretation

and how that might best be measured but also to an acceptance of the possibility that visitors might make new, unanticipated constructs on their own. Gradually, front-end evaluation has grown in importance as museums recognize that visitors are interested in and able to construct new understandings, if the information presented connects to their existing frameworks as described by Hans-Georg Gadamer (1975) and others.

These ideas are echoed in more recent voices. For example, in an article entitled "Transformation and Interpretation: What Is the Museum's Educator's Role?," Czajkowski and Hill describe "a museum model that has slowly been moving away from that of authoritative lecturer before a passive audience to that of a partner in dialogue with interested, engaged community members" (2008, 255). As the perceived role of the museum visitor has moved from one of information consumer to one of knowledge constructor based on active engagement, museums have increasingly become visitor-centric.

Two assumptions have started to gain attention in museums: first, that the role of museums is to support their community's ability to thrive by providing learning opportunities; and second, that museums provide opportunities, platforms, and materials from which visitors are able to construct their own meanings. If museums operate with these two assumptions, then their success rests on placing the visitor at the center of the interpretive planning effort.

As Judy discussed in "Comprehensive Interpretive Plans: The Next Step in Visitor Centeredness and Business Success?" (Koke 2008), museums, eager to demonstrate their public value and relevance, are coming to understand the increased need for planning that is strongly informed by community needs and voices. Museum practice is moving toward more institutionalized and formal interpretive planning and visitor research processes. Thus, being visitor-centric means developing plans and making decisions through the integration of two perspectives: that of the museum and its mission (formerly the sole voice) and that of the learner or visitor.

2.3. Theoretical Foundations of Interpretation

Understanding the theoretical foundations of interpretation, or how individuals make meaning, is fundamental for planning learning experiences. Theoretical foundations of interpretation are found across multiple academic disciplines, including communication theory, philosophy, developmental and cognitive psychology, recreation and leisure sciences, instructional design, and education. Examining how effective communication and learning theory coincide with informal learning is at the heart of discussions about the purpose of museums and is well captured

in Stephen Weil's *Rethinking the Museum* (1990), in which he explores the changing role of museums. And, as described earlier, the American Alliance of Museums strongly supports the notion that education is central to the purpose of museums (AAM 2008a). As museums have started to focus more on their audiences and on their educational purpose, attention to research and best practices in these areas has increased.

How Visitors Make Meaning

Scholars have long explored how individuals and societies make and communicate meaning, a field that came to be known as hermeneutics. Classically understood as the study and explication of texts (namely the Bible), in the first half of the eighteenth-century hermeneutics came to include the study of communication in all forms of written and spoken language, or what we would today call semiotics.

Gadamer's *Philosophical Hermeneutics* (1975) first described the assimilation of new ideas as an exchange or conversation between the "familiar" and the "unfamiliar," what Gadamer called a fusion of horizons. His work reshaped the field of education; as the father of philosophical hermeneutics, he explored not simply how individuals understood various ideas (in the sense of *which meaning*) but rather how (in the sense of *by what process*) individuals came to comprehend—that is, meaning making as a phenomenon. According to Gadamer, meaning making is the process by which the learner finds the ways that new ideas intersect and connect with his or her existing understanding. While the comment quoted below points specifically to art museums and works of art, we find that with a more general focus (see our substitutions in brackets) it sums up what some museum practitioners refer to as constructivist learning.

> What art museum [museum] teaching shares with the hermeneutics of Gadamer is the core premise that conversation and dialogue are the foundation for understanding and interpretation. . . . The unique charge of museum teaching is to bring people and works of art [objects] together face-to-face so that conversation can take place. . . . Within the play of dialogue, the object reveals itself. (Burnham and Kai-Kee 2011, 60–61)

In her 2008 article "Un/Familiar," Cheryl Meszaros focused on the work of Gadamer to illuminate the process of interpretation. Gadamer importantly had pointed out that any individual's experience in developing an understanding of a novel idea or concept (i.e., incorporating the unfamiliar into existing cognition) is necessarily shaped by the particular history and culture that shaped that individual (Meszaros 2008, 241).

This understanding was further explored in research of visitors' entrance narratives (Doering and Pekarik 1996) that established the importance of understanding the familiar, or visitors' starting points, and then also in science learning research that demonstrated the important role of personal experience and identity in science learning (Kozoll and Osborne 2004).

British psychologist Frederick Bartlett introduced a similar concept, the schema, in the early twentieth century (Bartlett 1932). A schema (*pl.* schemata; sometimes referred to as scripts) is a pattern of thought that organizes a person's current knowledge and provides a framework for future understanding. Piaget (1936) and other psychology and education scholars of the twentieth century used this term to describe the abstract mental structures that represent a person's understanding of the world. A schema is often described as mental Velcro (Hirsch 1996; Summers 1999), as the framework onto which new knowledge is affixed. In this way, learning happens on the fringes of what we already know. The important concept for our discussion is that understanding learners' existing knowledge and expectations is essential to helping them make meaning from new ideas and concepts.

Educators and psychologists, including Jean Piaget (1969), Lev Vygotsky (1978), Malcolm Knowles (1973), Howard Gardner (1993), and David Kolb (1984), have continued to expand the theoretical notions of learning and meaning making and how different people approach, engage with, and incorporate new ideas. These learning theories were connected to informal learning and museums in part by critical work on meaning making done by Lois Silverman (1995). Her work helped move museums from thinking about effective transmission of ideas to creating spaces where visitors create meaning. The shift in thinking was reinforced that same year by Hein's *The Constructivist Museum* (1995). Museum practitioners began to conceive of their work differently, recognizing that if museum visitors engage with objects and exhibits in the context of their own entrance narratives, then museum work is less about fact and idea transmission and more about the opportunity to explore and shape individual world views and experiences (see also Hein 1998). Additionally, the work of Leinhardt and colleagues (2002) and Borun and colleagues (1997) underscores the importance of conversation as both process and product in museum learning. This work has resulted in thoughtful suggestions for creating spaces and experiences that promote social learning behaviors and conversation.

The use of the schema concept and other frameworks noted above underpin the development of diverse engagement opportunities for visitors. Being able to offer strong learning or meaning-making opportunities is rooted first in an understanding of how meaning making happens (i.e., hermeneutics) and a deep understanding of the way learning is

facilitated in informal learning environments, and, additionally, in using that knowledge to plan and develop opportunities that exemplify those understandings.

2.4. PLANNING FOR INTERPRETATION AND LEARNING

While the act of interpretation, defined by most common dictionaries as the action of explaining the meaning of something, is as ancient as human communication (Pond 1993), the formal practice of interpretive planning in the museum profession is a relatively recent development. Its use within federal land management agencies (e.g., the U.S. National Park Service, Forest Service, and Bureau of Land Management) grew out of increased public awareness of environmental issues in the 1960s and 1970s and related federal legislation that mandated public involvement in land-use planning and decision making (e.g., Multiple Use and Sustained Yield Act of 1964, Wilderness Act of 1964, National Environmental Policy Act of 1969). As one agency affected by these changing public sentiments, the National Park Service (NPS) published its first *Interpretive Planning Handbook* in 1965 to guide the design and production of interpretive media.[6] The 1960s and 1970s were later termed the Golden Age of interpretive media development in U.S. national parks. In 1983, the NPS (Harpers Ferry Center) published a revision of the *Interpretive Planning Handbook*. This manual describes interpretive planning as a process

> that analyzes the need for programs, facilities, media, and personal services to communicate information to park visitors. It is a process that defines objectives, examines various options and alternatives, and considers the financial, and possibly environmental, consequences of the proposals. It enables management to make informed decisions long before interpretive programs or facilities are developed and enables the allocation of the resources necessary to implement the plan. (NPS 1983, 1)

In 1988, in conjunction with its seventy-fifth anniversary, the NPS published *The Interpretive Challenge*, in which it identified goals for enhancing interpretive planning. In 1996, the NPS published a guideline for interpretation and visitor services entitled *Interpretive Planning* (NPS 1996). This document defined interpretive planning as a "strategic process which, in its implementation, achieves management objectives through interpretation and education" (NPS 1996, 5) and set forth basic principles of interpretive planning. With this document, the NPS adopted a unified planning system employing comprehensive interpretive plans (CIPs). A CIP was to be a park-specific plan that contained

a long-range interpretive plan (LRIP), an annual implementation plan (AIP), and an interpretive database (ID). By 2000 much of the responsibility for interpretive planning was shifted from the Harpers Ferry Center in West Virginia to individual parks, although planning in collaboration with the national support centers in Harpers Ferry and Denver still occurs.

Although few other land management agencies have as rich a history in interpretive planning as the NPS, hundreds of national, state, county, and municipal outdoor recreation and natural resource agencies produce interpretive plans for visitor experiences with parks, forests, nature centers, lakes, rivers, protected areas, open space, and natural areas. Somewhat surprisingly, the less well-developed practice of interpretive planning in museums and informal settings has evolved independently of that in natural resource agencies, although in a few instances these disciplines are beginning to inform one another.

In 2005, the American Association of Museums (AAM) convened a National Interpretive Planning Colloquium in Indianapolis, Indiana, the purpose of which was to entertain discussion and deliberation about the format and practice of interpretive planning for museums. Characteristics of an intellectual framework as well as ideas for planning outlines and checklists were discussed; however, no official documentation or guidance resulted from this colloquium. Interpretive planning within museums has yet to become a widely recognized process. Direction and frameworks do exist, but nearly all of them come from disciplines within natural resources, recreation and parks, leisure studies, interpretive services, and environmental education. For example, Veverka's *Interpretive Master Planning: The Essential Planning Guide for Interpretive Centers, Parks, Self-Guided Trails, Historic Sites, Zoos, Exhibits and Programs* (1994) was developed primarily for interpreters in natural resource settings (e.g., national parks, municipal recreation and parks districts, nature centers). It borrows from an early model of interpretive planning originally proposed by Peart and Woods (1976) that is described in Veverka's book as the What, Why, Who model of planning. Veverka also discusses principles of interpretation proposed by Tilden (1957) and describes the process of planning in a variety of interpretive situations. In 2011, Veverka published a two-volume set entitled *Interpretive Master Planning* that uses the same planning model but slightly embellishes the processes described in the 1994 book; a set of selected essays by the author that discuss scenic byways, heritage sites, heritage tourism programs, interpretation as a management tool, and several other topics concerning interpretation (as used in the natural resources professions) comprise the second volume.

Lisa Brochu's *Interpretive Planning: The 5-M Model for Successful Planning Projects* (2003, 3) defines interpretive planning as "the decision-making process that blends management needs and resource considerations with visitor desire and ability to pay (with time, interest, and/or dollars) to determine the most effective way to communicate the message to targeted markets" and proposes a model that "is a marriage of management, message, market, mechanics, and media"— the 5-M model. The book distinguishes types of plans, discusses the process for planning, and provides useful examples throughout. Though not targeted to museums directly, these few interpretive planning resources provide additional material for planning ideas and inspiration.

Interpretive Planning

Throughout the literature, interpretive planning is variously referred to as an approach, a document, a process, and more, as illustrated by the following examples (some paraphrased, some quoted; italics added).

Interpretive planning is . . .

. . . *a written document* that outlines the stories and messages the museum wants to convey through a variety of media such as exhibits, programming, and publications. It may include the institution's interpretive philosophy, educational goals, and target audiences. (AAM National Interpretive Planning Colloquium, May 5, 2005, unpublished presentation)

. . . *"an interdisciplinary approach* whose end goal is to promote more dynamic interaction between visitors and objects." (Maurer 2008, 233)

. . . *a living document* that serves to proactively guide a museum's interpretation. (Hakala 2008)

. . . *a document* that defines or articulates the intellectual framework that connects the mission of an organization and its collections with the needs and interests of its audiences. Shaped by the strength of its collections, mission, and core values, it describes the organization's unique role in the life of a community. (Adams and Koke 2008)

. . . *"a strategic process* which, in its implementation, achieves management objectives through interpretation and education; *a goal-driven process* which describes visitor experiences and recommends appropriate means to achieve them while protecting and preserving park resources." (NPS 1996, 4)

. . . *a way of setting out* how a museum intends to communicate with its visitors and other users through its displays, exhibitions, and other activities and how it aims to cater to a variety of learning styles and needs. (Swift 2002)

In 2008, Judy and her colleague Marianna Adams edited an issue of the *Journal of Museum Education* that focused specifically on institution-wide interpretive planning (Koke and Adams 2008). This volume contains 10 planning-related essays by select authors on topics ranging from transforming the educator's role in museums to institutional planning at a fine arts museum. The various essays provide several definitions for interpretive planning and offer a variety of different perspectives on planning. This special issue was produced in part as a response to the 2005 AAM colloquium on interpretive planning but also in recognition that institution-wide interpretive planning was entwined with contemporaneous discussions about transparency in public institutions and defining individual museums' public value. Still, however, definitive guidance for planning visitor experiences in museums is rare. In the next chapter, we offer a comprehensive definition of interpretive planning, give a brief history of it, and describe a deliberate process for interpretive planning discussions and decision making.

Chapter 3

INTERPRETIVE PLANNING

3.1. DEFINITION

As we have described in Chapter 2, interpretive planning has been given a wide variety of definitions. Some see it is as a process, others as a plan. We define interpretive planning as follows:

Interpretive planning is a deliberate and systematic process for thinking about, deciding on, and recording in a written format or plan educational and interpretive initiatives for the purpose of facilitating meaningful and effective experiences for visitors, learning institutions, and communities, where,

- *deliberate and systematic* means that the process is intentional, thoughtful, and methodical;
- *process* refers to an ongoing and enduring course of action, a procedure that embraces change and opportunity;
- *thinking* means that the planner (individual or team) exercises the power of reason in order to arrive at judgments or decisions; *thinking* also encompasses deliberation with others who are involved in the process;
- *deciding* means engaging in a process of decision making in which the planners, in collaboration with or influenced by other people, organizations, and entities who may be affected by the plan, come to a determination about provisions in the plan;
- *recording* means communicating in written form (print or electronic) the deliberations, decisions, and other provisions of the process in an organized and reasonable manner;
- *plan* refers to the document (which may be a digital text file) that serves as an administrative record of the planning effort;
- *educational and interpretive initiatives* refers to the activities and projects (e.g., exhibits, programs, educational media, outreach) that attract, engage, teach, and inspire visitors;
- *purpose* refers to the intent or function of the plan;

- *meaningful* and *effective* describe the consequence of experiences, in this case, the specific outcomes and impacts of informal learning experiences, which may be positive, negative, or unintentional, and which involve changes to or transformations in a person's cognitive, affective, psychomotor, or social domains (see Chapter 4 for more on these domains);
- *visitors*, *learning institutions*, and *communities* describe the beneficiaries of the plan; those who derive benefit from the planning process and the plan's final recommendations.

As this definition illustrates, interpretive planning involves both a process and a written record, and it is accomplished for an explicit purpose: to explicate visitor experiences.

Interpretation (Education and Learning) versus Interpretation (Collections Research)

The natural resources and recreation disciplines have traditionally used the term *interpretation* to refer to the creative presentation of themes and informal education in parks and natural areas (see Section 2.4). In museums, however, curators have also used the term to describe how scholars tease out the meaning of an object or artwork as the result of research. Relatively recently, due in large part to the increasing attention paid to interpretive planning, *interpretation* has become more recognized in museums as a term that suggests education, visitor experiences, and informal teaching and learning in museums; and it is in this way that we use the term in our discussion.

In *Secrets of Institutional Planning*, Merritt and Garvin (2007) answer in broad terms the question: Why plan? They assert that museums plan in order to set common priorities and take control of their future, inspire collective effort toward a common goal, stimulate thinking, prevent disaster, set the stage for measuring success, provide a road map, and ensure their survival. Interpretive planning serves similar purposes but along with others, perhaps the most important being accountability, which requires creating a written administrative record for decision making related to visitor experiences and learning opportunities. As was acknowledged at the 2005 AAM colloquium, interpretive planning needs to be reflective, ongoing, inclusive, and documented.

Interpretive planning also provides the foundation for following a strategic, intentional, and integrated approach to discussing and making decisions about learner experiences with an institution. It encourages reflective practice on the part of the organization to examine, discuss,

and develop thoughtful prescriptions for meaningful learning experiences. In general, interpretive planning

- provides an intellectual framework that connects an organization's unique mission and collections with the needs of its audiences;
- provides clarity and strength of direction for interpretation and educational media and programs;
- provides holistic priorities to guide decision making when inevitable budget questions are addressed;
- facilitates communication among museum staff to ensure that (a) all staff are aware of educational and interpretive goals and ideas of the institution, (b) staff understand their institutional roles in relation to visitor experiences, and (c) various parts of an institution (galleries, buildings, sites, departments) are integrated in a unified vision for visitor engagement and learning;
- ensures that institutional stories are relevant and obvious not only to visitors but also to funders, community members, business leaders, and government officials;
- ensures that exhibits are thematic, relevant, appealing, and accessible to diverse audiences; and
- recommends in a clear, logical, and rational manner appropriate interpretive services, facilities, programs, and media (i.e., delivery systems) for effectively communicating the institution's purpose, significance, compelling stories, and values, while also protecting and preserving institutional resources.

As we have already noted, systematic interpretive planning is an infrequent practice in museums. This may be because museum staff have little understanding of interpretive planning, but it may also be because they are receiving confusing messages about planning and decision making or because there is little interest in or time for planning. To help overcome these barriers, we offer the reader a framework for thinking about interpretive planning, with a focus on and rationale for incorporating visitor perspectives and, particularly, desired visitor outcomes. We wish to underscore, however, that there is no single, universally accepted or approved process of interpretive planning for museums. The sequence of discussion and decision categories that we present later in this chapter (see Figure 3.2) and in Chapters 5 and 6 is intended to be suggestive rather than prescriptive. Readers are encouraged to adapt the suggested processes to suit the idiosyncratic needs of the specific organization or project.

3.2. Scope and Scale of Planning

Planning in museums occurs at a variety of different scales, each requiring different types and degrees of information. For example, most museums have a strategic plan that guides the organization's overall direction, as opposed to its day-to-day operations. Broad in the sense that it is about the entire organization, the strategic plan addresses big-picture goals, timelines, and budgets. Other plans, such as a collections plan or a staffing plan, may be institution-specific and are more narrow in focus and specific in detail. Likewise, an interpretive plan can be institution-wide, addressing strategic level thinking, or project-specific, addressing details related to an exhibit, activity, or program. Therefore, it is useful to begin a discussion of interpretive planning with a consideration of various scales of planning. Figure 3.1 arrays three scales for interpretive planning.

Regional or Community Planning

On the regional or community level, interpretive planning is broad, conducted collaboratively among organizations, agencies, or other entities in a deliberately defined geographic area, and does not go deeply into detail (Figure 3.1, top). Although interpretive planning on this scale is not common, it is gaining some attention nationally. Museums and other nonprofit cultural institutions are expressing interest in this type

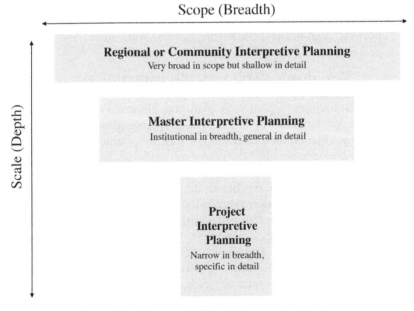

Figure 3.1 Scope and Scale of Interpretive Planning

of planning, in large part because for many organizations shrinking budgets necessitate more collaboration. As museums look across the learning landscape, increasingly they are recognizing that collaboration and resource sharing to achieve similar goals is an attractive option. The city of Victoria, British Columbia, for example, created an interpretive plan for its community that guides the work of all the parks and heritage sites in its purview (CRD 2003). As a second example, the Hub, Home, Heart: Greater H Street NE Heritage Trail in Washington, DC, part of the District of Columbia's Neighborhood Heritage Trails project, aims to preserve and interpret regional heritage in that city. In a third example, sixty cultural institutions in southern California collaborated in a regional temporary exhibition (October 2011 to March 2012) in Los Angeles entitled Pacific Standard Time: Art in LA 1945–1980, designed to interpret and celebrate the birth of the Los Angeles art scene.

While we acknowledge the regional scale of interpretive planning and its significant potential for broad, regional collaboration about visitor experiences and learning, we will not discuss it at length. We point it out among the scales of planning, however, in hopes that this may catalyze some interest, as museums increasingly acknowledge their role as essential educational institutions and partners in community teaching and learning.

Master Interpretive Planning

An institution-wide interpretive plan (Figure 3.1, center) is narrower in scope and more specific in detail than a regional plan. Like a strategic plan, it addresses the entire institution, proposing an overall strategy for visitor experiences and providing general guidance for programs, activities, and exhibitions. For example, in 2008, the Royal British Columbia Museum in Victoria, British Columbia, Canada, developed a comprehensive Vision for the Visitor Experience, an institutional interpretive plan for guiding educational efforts within the organization over a five-year planning horizon. Though institution-wide interpretive planning is now just gaining traction among museums, it is essential not only for fully realizing the broad educational mission of an institution but also for reinforcing the collective educational value of museums nationally.

Master Interpretive Plan

Institution-Wide Interpretive Plan, Long-Range Interpretive Plan, Comprehensive Interpretive Plan, Interpretive Strategy, Interpretive Framework, Community Connections Plan, Museum-Wide Exhibition Master Plan

Although there are several terms used for this sort of planning, the term *master interpretive planning* will be used in this discussion to designate institution-wide planning that addresses broad institutional goals, a full and extensive inventory and analysis, and a general direction for educational programs and media.

A master interpretive plan might spawn any number of more specific exhibition or program plans during the time horizon set forth in the broader strategy. Furthermore, the master plan will most likely address the institution's approach to both interpretation (e.g., public programs, exhibits, publications, websites) and education (e.g., K–12 school programs, activities, curricula, field trips). Depending on the size and nature of the institution, however, this plan may also address orientation and wayshowing (signs and directions), communication, marketing messages, volunteer training, and customer services. We provide a more comprehensive discussion of master interpretive planning in Chapter 5.

Project Interpretive Planning

Project planning for exhibits, activities, or programs (Figure 3.1, bottom) is narrow in breadth and specific in detail and is the most common type of planning in museums. Many museums have an established practice for developing exhibitions and education programs, and some proceed without the benefit of an overarching master interpretive plan. In some cases, project interpretive planning and exhibit development are considered synonymous; however, we argue they are not. The addition of deliberate planning steps prior to exhibit development distinguishes what we consider to be project interpretive planning.

Project Interpretive Plan

Interpretive Exhibit Plan, Short-Term Interpretive Plan, Exhibit Plan, Interpretive and Educational (I&E) Plan

In concept, a project interpretive plan should be generated from a master interpretive plan. It will be narrower in scope and should describe in far greater detail such aspects as the project background, goals, inventory and analysis, themes, and visitor experiences for that particular project. We discuss project interpretive planning in more depth in Chapter 6.

Adapting a planning summary offered by Merritt and Garvin (2007), we indicate in bold italics in the list below where master interpretive planning and project interpretive planning fit within a full range of museum plans.

Plans about the Whole Institution
Strategic Plan
Institutional / Long-Range Plan
Master Plan
Operational Plan
Master Interpretive Plan

Plans Related to Finances, Fund-Raising, Public Relations and Marketing
Capital Campaign Plan
Marketing, Communications, Outreach Plans
Development or Fund-Raising Plan
Financial or Business Plan
Investment Plan

Plans Related to Collections, Interpretation or Education
Collections Plan
Conservation Plan
Furnishings Plan
Project Interpretive Plan
Research Plan

Plans Related to Management and Operations
Diversity Plan
Staffing Plan
Transition Plan

Plans Related to Facilities
Maintenance Plan
Emergency Response or Disaster Plan
Historic Structure Master Plan or Restoration Plan
Housekeeping Plan
Landscape Plan
Restoration Plan
Site Plan

Not all institutions have all of these plans nor should they, but this summary is intended to clarify the distinction between the more specific and the more general scales of interpretive planning.

As defined above, interpretive planning is the deliberate and systematic process for thinking about, deciding on, and recording in a written format or plan educational and interpretive initiatives for the purpose of facilitating meaningful and effective experiences for visitors, learning institutions, and communities. The purpose of interpretive planning is to inspire intentioned thought, careful decisions, and a proactive, coordinated effort toward the goal of providing engaging and meaningful visitor experiences. The scale of planning does not change the need to ask questions of ourselves and our visitors. Regardless of scale,

interpretive plans always benefit from some measure of visitor input to ensure correspondence between the institution's "we could" and the community's "we need" or "we want," thus aligning practice with a visitor-centered philosophy. The scale only changes the specific types and amounts of information to be gathered when answering planning questions.

The eventual uses for an interpretive plan can vary depending on the scale of plan and also on institutional needs. Furthermore, interpretive plans should not be static documents; rather, museum professionals should view them as dynamic and useful tools for guiding the development and implementation of interpretation for their institution. An interpretive plan is useful as:

1. A *decision tool* for organizing and guiding decisions about meaningful and sustainable visitor experiences with your institution.
2. A *development tool* to demonstrate to potential donors and funders that your institution is being clear and strategic about its visitor experiences; that you are deliberately and proactively planning a constellation of well-conceived opportunities for visitors to your institution.
3. A *monitoring tool* to track progress over time with regard to education and interpretation efforts, and to provide benchmarks against which future initiatives may be compared and evaluated.
4. A *marketing tool* to showcase visitor experiences within the institution and also to stimulate interest in your institution as a meaning-maker in your community or region.
5. An *implementation tool* for guiding and contracting design-development, fabrication, and implementation efforts.

3.3. PLANNING TEAM CONSIDERATIONS

The best interpretive plans, regardless of scope, are pursued as team efforts, and the best teams are composed of individuals from both inside and outside the institution. The planning team should value diverse expertise and consider multiple viewpoints, including but not limited to management and administration, education, curatorial and collections, marketing, design, facilities, visitor services, and visitor studies and evaluation. A good team will also include collaborators from outside the institution such as teachers or content specialists from schools or universities, specialized staff from other museums, or specialists from aligned organizations in areas such as recreation and leisure, tourism, city or

county government, or the private sector. In sum, a master interpretive plan should not be insular either departmentally or institutionally.

Depending on the size of the organization, a planning team can be between five and ten people, although often the fundamental work is done by only two or three people and then is shared or vetted with other staff as appropriate. The larger group often functions as an advisory team or a group that integrates the project into all areas of the museum. In addition, for efficient and successful interpretive planning there is typically one person who serves as the primary coordinator and point of contact for the planning effort. This person, who typically orchestrates the process and coordinates all the pieces, should be someone who is passionate about visitors and learning and can easily envision the ultimate outcomes of the plan across the time span of the project. This person may also assume responsibilities for

- providing a thorough and accurate administrative record of the planning effort (tracking the progress of planning throughout);
- facilitating a logical, inclusive, and efficient planning process, including discussions among planning team members;
- involving the public at appropriate times and in reasonable ways while also monitoring those involvements throughout the project;
- delivering a high-quality, professional plan that is useful to the institution;
- helping facilitate the transition from planning to development and use; and
- addressing any leadership, administrative, and organizational considerations that should be in place to ensure the successful implementation and sustainability of the plan.

3.4. INTEGRATING VISITOR PERSPECTIVES INTO INTERPRETIVE PLANNING

One highly desirable goal for museums is the complete institutionalization of an audience- or visitor-centered approach into all phases of project planning and development. This requires a visitor-centered perspective from the outset and the integration of visitor perspectives throughout planning and decision making. Being visitor-centric means that there is a shared sense among the staff of an institution that the visitor experience is important to the mission of the organization.

Educators and program developers in museums, science centers, and other informal learning settings have long had an interest in understanding the impact that exhibits, programs, and publications

have on their visitors. The impetus is accountability, and the desired result is more successful (i.e., engaging and meaningful) informal learning experiences. Gradually, administrators, funders, community leaders, and others are recognizing their stake in exploring and documenting the impact of informal learning activities. Thus, the audience is broadening, and museums are increasingly recognizing themselves as valuable educational institutions and important community assets.

With this in mind, there are many right ways to plan. For the most part, planning of all types is linear in logic, although it can often seem chaotic in process. A plan develops gradually as the planners gather and discuss information and ideas, and it evolves as they address sequential planning questions and collectively capture answers in written form. Planning is iterative in the sense that, although the logic remains linear

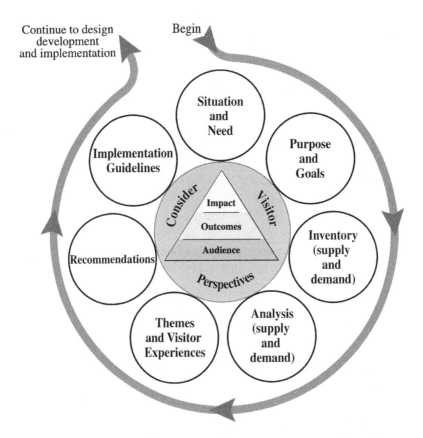

Figure 3.2 Sequence of Interpretive Planning Discussions and Decisions

(moving from need to goal to recommendation by way of information gathering and analysis, as indicated in Figure 3.2), the collection of information and the discussion of ideas sometimes require planners to revise, adjust, and adapt their earlier ideas and thoughts as they proceed.

In many cases, planners pose questions from an institution's perspective; for example, what stories do we want to tell based on the collections we have? However, as institutions become more visitor-centric—broadening the planning questions to consider the visitor perspective and even community perspectives—they may reframe the question to, what stories do visitors want to hear that our collections could tell? Thus, the approach presented in Figure 3.2 offers a practical way to plan interpretive and educational initiatives for museums, at both an institution scale and a project scale. More importantly, this approach addresses when and how to integrate audience perspectives in the course of planning. In the following sections we summarize the approach briefly; then in Chapters 5 and 6 we elaborate on and provide detailed examples of the approach as used for master interpretive planning, and project interpretive planning.

Situation and Need

The first part of a plan should address the current situation and the need for the plan. Depending on the scale of plan, it might answer questions such as: Who are we, and why are we doing this plan? What institutional history, background, or context is important for this planning effort? What is unique or compelling about our institution? How will the plan address the strategic mission of our institution while meeting the needs of our community and our visitors? What community or institutional need or interest do we hope to serve? What problems or issues is the plan attempting to address?

Purpose and Goals

Once the context for the plan is explicated and the need identified, planning questions turn to purpose and goals. From an internal perspective, the plan must address the explicit purpose of the planning effort. From a visitor perspective, however, the plan also must address questions such as: What difference will the realization of this plan make for visitors, the community, underserved audiences, and perhaps broader audience sectors? Or, said another way: How will the institution, community, and audience be changed by the outputs of this planning effort? What general impacts are relevant and expected for this planning effort?

Inventory

The goal of the inventory is to address questions about current available resources and information, considering both supply and demand. The terms *supply* and *demand* are borrowed from an oft-used market or economic model in which *supply* refers to all available assets, and *demand* refers to demonstrated need or desire. Thus, for interpretive planning, inventorying supply involves asking: What do we know about our current assets—collections, staff, budget, facilities, materials, management philosophies, issues, concerns, documentation related to education, marketing, research—that relate to creating visitor experiences? Inventorying demand means asking: Who represents the need or desire for the institution's goods and services? Who are our past, present, and anticipated future visitors? What target markets do we serve? What future visitation do we want? Who is not being served but may be a potential audience? From a visitor perspective, demand inventory also addresses questions related to what visitors know or don't know, are or are not interested in, care about or don't care about. In many cases, visitor studies (particularly front-end evaluation) can provide data and information related to these questions.

Analysis

At the analysis stage the team has gathered and presumably summarized in writing quite a bit of information and data: information about the current situation, about the plan's purpose and goals, and about supply and demand. Questions at the analysis phase are about what the combined information and data tells us. This is a period for reflection, deliberation, and discussion among planning team members, and perhaps with other stakeholders, to consider the implications of the information that has been gathered thus far. For example, what does that information suggest about possible themes or desired visitor experiences? What implications does it have for decisions about particular media for telling the story? And, considering the visitor perspective, what implications does the inventory have for eventually developing visitor outcomes?

We use the term *demand analysis* to describe the process of inventorying and analyzing data and information about a museum's visitors; the term may be more familiar to natural resource interpretive planners than to museums. Demand analysis is an enhanced form of what some museums call *front-end evaluation*. It combines exploring visitors' entrance narratives along with marketing data and analyzes both to paint a reasonable picture of the audience and their demand for the museum's goods and services.

Themes and Visitor Experiences

Theme

Compelling Story, Statement of Significance, Main Message, Big Idea, Storyline

As a result of the inventory and analysis stages, themes, key messages, and associated visitor experiences will start to become apparent. Master interpretive planning themes and intended visitor experiences are broad and pertain to the entire site or institution, whereas project interpretive planning themes address the more specific stories (and subordinate key messages) that may be appropriate and viable for the particular project. In either case, following inventory and analysis, planners will develop themes to align the story to be told with the educational and interpretive media and products to be created. Also, visitor opportunities begin to emerge, and thus outcomes can be considered.

Recommendations

The next phase of the planning process involves identifying broad options for delivering educational and interpretive messages. In some cases, planners will want to consider multiple alternatives (and commensurate decision criteria) before making final recommendations. Eventually, they will need to detail specific goals, themes, visitor experiences, desired visitor outcomes, and design implications for each recommended option.

Implementation Guidelines

Implementation guidelines provide a transition to implementation, in the case of master planning, or to design development, in the case of project planning. They also provide information about budget, scheduling, materials, and effort needed to implement the final recommendations of the plan regardless of the scale. Consideration of implementation guidelines at this phase ensures that planners can realistically schedule and budget for the coordination of staffing, resources, seasonality, and evaluation.

Following an in-depth look at visitor perspectives in the next chapter, we will return to a discussion of integrating visitor perspectives in interpretive planning for two scales of planning: master interpretive plans (Chapter 5) and project interpretive plans (Chapter 6).

Chapter 4

THE OUTCOMES HIERARCHY

4.1. VISITOR PERSPECTIVES AND THE NATURE OF OUTCOMES

As profits are to a business, so outcomes are to a museum.

Stephen Weil (2003)

Visitor perspectives is a collective term for a multitude of points of view among museum visitors, current and potential, representing a broad array of demographic, social, and psychographic characteristics. For museum professionals, the concept of visitor perspectives means taking into consideration differing levels of knowledge, cultural backgrounds, attitudes, and other factors when planning visitor experiences. Recent changes in pedagogy underscore that learning starts with learners—where they are in terms of their prior experiences and motivations—and emphasizes the importance of becoming familiar with and building on those perspectives.

Integrating visitor perspectives in interpretive planning means that planners are able to:

- think through the museum experience from the point of view of the visitor. For example: What is it like to find parking when visiting a museum in a crowded city? What is it like to enter a new museum for the first time? How does it feel to return to your favorite museum with your grandson in tow? What is it like to be a 6-year-old child and see Sue, the world's best preserved Tyrannosaurus rex at Chicago's Field Museum for the first time?
- include visitor input into their thoughts, discussions, and decision making regarding visitor experiences. This may include reading or referencing secondary data sources about visitors or collecting primary data from visitors as part of a visitor studies effort.
- listen to and for the visitor's voice at all times while planning, designing, and creating experiences and opportunities for visitors.

Wells, Marcella, Barbara Butler, and Judith Koke. "The Outcomes Hierarchy." In *Interpretive Planning for Museums: Integrating Visitor Perspectives in Decision Making*, 51–70. ©2013 Left Coast Press, Inc. All rights reserved.

- imagine and integrate diverse visitor needs, motivations, and preferences in planning visitor experiences.
- imagine audiences broadly and recognize that they represent many different backgrounds, interest levels, entrance narratives, and learning styles.

In considering desired outcomes of a project, planners should apply what they have gathered regarding visitor perspectives in order to best articulate the anticipated result of a visitor's experience. According to United Way of America's Task Force on Impact (Hatry et al. 1996, xv) outcomes are defined as the "benefits derived by participants during or after their involvement in a program." They relate to changes in a person's knowledge, feelings, attitudes, behavior, or skills. In a museum context, they are what participants do, think, or feel during or following a museum experience. The ultimate purpose of thinking about outcomes is to describe intended change and to determine, through evaluation, the extent to which these desired results are achieved. Outcome statements are used in areas such as health care, social services, and formal education to articulate the desired effect of programs or activities. For museums, they are worded from the perspective of the visitor. An institution that articulates desired outcomes of a project demonstrates that it understands the importance of incorporating visitor perspectives into its thinking about and planning of visitor experiences.

In his article "Transformed from a Cemetery of Bric-a-Brac," Stephen E. Weil (2000) argues that the reframing of the traditional museum from an inwardly orientated institution that acquires, cares for, displays, and studies collections, to one that serves the public is among the most important changes of the twentieth century for the museum world. This, he said, resulted from the emergence of a new organizational concept of "the social enterprise" and new modes of organizational assessment in which "the ultimate operational objective for the social enterprise—its bottom line—is a positive social outcome" (Weil 2000, 7).

As we have already discussed, in the late 1980s and the 1990s several initiatives began to converge with a shifting pedagogy from learner as recipient of information to learner as constructor of meaning; for example, the Visitor Studies Association was becoming a viable professional organization, the role of museums as a social enterprise in communities was gradually taking hold based on Weil's work, and federal granting agencies and some informal learning institutions were beginning to recognize the importance of measuring impacts and outcomes. An important stimulus for this convergence was the 1993 passage by the U.S. Congress of the Government Performance and Results Act (GPRA). As mentioned in Chapter 1, this act stimulated program performance

reform by mandating that organizations must clearly state program goals, develop program performance measures, and then publicly report progress related to those goals. The overall intent of GPRA was to improve federal program effectiveness and public accountability by recalibrating the focus on results, service quality, and customer satisfaction. The ripple effect that reached federal granting agencies (e.g., the National Science Foundation, Institute of Museum and Library Sciences, National Endowment for the Arts) has ultimately impacted their funding application processes and the types of applications submitted, including those from informal learning organizations (Timberlake 1999). Most project applications now require some articulation of intended outcomes. This consequence of the GPRA legislation has been an important consideration as we conceived and developed our Outcomes Hierarchy.

In 1996, the United Way system of charitable organizations made a major contribution to the field of outcome-based evaluation with their publication *Measuring Program Outcomes: A Practical Approach* (Hatry et al. 1996). Rather than dwell on the traditional output question, how many people did our programs serve?, this book addressed the more relevant question, what difference do our programs really make in people's lives?

Subsequently, resources and guidance regarding outcomes became more widely available. For example, agreeing that consideration of outcomes holds important value for their museum and library constituents, the Institute of Museum and Library Services (IMLS) in 2000 published the small booklet *Perspectives on Outcome Based Evaluation for Libraries and Museums.* Shortly thereafter IMLS developed several related resources and workshops. Similarly, the National Science Foundation (NSF) helped fund an online resource (www.informalscience. org) for posting and discussing research and evaluation projects, many of which involve measuring outcomes. In 2008, NSF published *Framework for Evaluating Impact of Informal Science Education Projects,* which discusses outcome evaluation and outcome categories (e.g., awareness, knowledge or understanding, engagement or interest, attitude, behavior, and skills[7]). Although terms and definitions related to outcomes and outcomes-based evaluation are somewhat inconsistent throughout the literature, the intent is clear: organizations like NSF, IMLS, and others endorse outcomes-based evaluation and support efforts toward that end. Pekarik (2010), however, suggests moving beyond focusing on outcomes, that they are only one piece of the broader visitor perspectives notion. Similarly we suggest that when we take that piece and integrate it into interpretive planning, outcomes can be useful for guiding intent, tracking progress, and building awareness about visitors in informal learning organizations.

4.2. The Outcomes Hierarchy

The graphic arrangement of concepts and tasks that we have developed and have dubbed the Outcomes Hierarchy (Figure 4.1) features a hierarchical relationship of potential outcomes commonly considered in museum education. The original purpose of the hierarchy, as presented in our earlier publications (Wells and Butler 2002; 2004), was to place outcomes in the larger context of evaluation. It is highlighted here because of its value in organizing thinking and discussion about integrating visitor perspectives in museum planning.

The Outcomes Hierarchy consists of four major tiers organized in a triangle. The bottom tier addresses the kind of audience data and information that are often gathered by marketing departments, sometimes as part of an organizational strategic planning process, for a marketing plan, or perhaps for a funding proposal. The upper three tiers address the anticipated results of visitor experience opportunities at the levels of outputs, outcomes, and impacts. In a column on the right are variable details relevant to each level, and in a column on the left are broad questions that help focus thinking, planning, and evaluation at each level. Each tier of the hierarchy is discussed in more detail below.

Tier 1. Audience Data and Information

The lowest tier, audience data and information, includes both demographics and psychographics. Demographics are statistical characteristics of a population, for example, age, gender, level of education, income, home zip code, ethnicity, visiting group size, and distance traveled. Frequently, institutions use surveys to collect these data; for example, many museum marketing departments collect demographic facts about members, current visitors, school groups, and occasionally about nonvisitors. Psychographics is the study of personality, values, attitudes, interests, motivations, opinions, and lifestyles. Psychographic information can be captured using surveys or interviews but also using focus groups, concept maps, or visitor panels, to develop psychographic profiles of visitors or of an audience segment. Both demographics and psychographics can be inventoried as part of a front-end evaluation strategy to inform planning efforts. These data are particularly useful for understanding and discussing visitors' entrance narratives.

Demographic and psychographic information can be collected as primary data or secondary data. Primary visitor data are collected directly from the users (visitors in our case) via random selection surveys, interviews, guest logs, or membership mailings. However, since these methods can be costly and time-consuming, acquiring visitor data from secondary sources is often more efficient. Secondary sources provide data that describe people who are similar to the intended users or the targeted

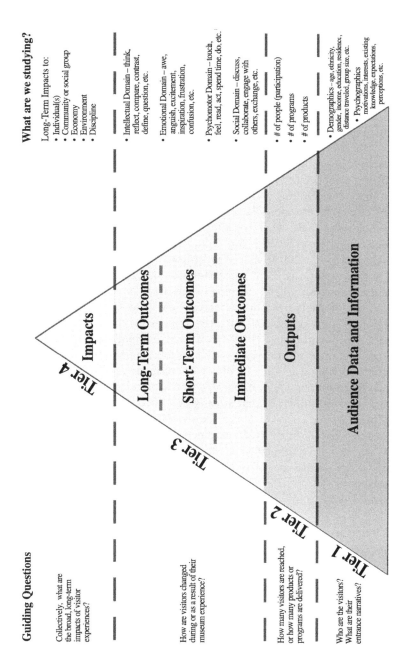

Figure 4.1 Outcomes Hierarchy

Guiding Questions

Collectively, what are the broad, long-term impacts of visitor experiences?

How are visitors changed during or as a result of their museum experience?

How many visitors are reached, or how many products or programs are delivered?

Who are the visitors? What are their entrance narratives?

Tier 4 Impacts

Long-Term Outcomes

Short-Term Outcomes

Immediate Outcomes

Tier 3

Tier 2

Outputs

Tier 1

Audience Data and Information

What are we studying?

Long-Term Impacts to:
- Individual(s)
- Community or social group
- Economy
- Environment
- Discipline

- Intellectual Domain – think, reflect, compare, contrast, define, question, etc.

- Emotional Domain – awe, anguish, excitement, inspiration, frustration, confusion, etc.

- Psychomotor Domain – touch, feel, read, act, spend time, do, etc.

- Social Domain – discuss, collaborate, engage with others, exchange, etc.

- # of people (participation)
- # of programs
- # of products

- Demographics - age, ethnicity, gender, income, education, residence, distance traveled, group size, etc.
- Psychographics - motivations, interests, existing knowledge, expectations, perceptions, etc.

audience segments. These types of inventories are underexplored in many cases. Census reports, travel industry reports, museum friends' group reports, community interest group data, education agency reports, and recreation and leisure reports are examples of valuable data sources. Even if visitor data do not exist for your institution specifically, there may be similar demographic or psychographic information available for your community, region, or state in comparable reports or databases (see Haas et al. 2007, 10, and more generally, 20–30 for how to develop an information atmosphere of secondary resources). Consulting multiple sources (for example, census data, tourism data, and education data) may provide a reasonably triangulated description of visitors.

Existing audience research and informal learning frameworks are useful for informing thinking and discussion about audiences and their preferences. Deborah Perry describes six motivations, in her Selinda Model of Visitor Learning, that "work together, resulting in intrinsically motivating visitor experiences" (2012, 66). John Falk's *Identity and the Museum Visitor Experience* (2009) describes visitors' motivations and related needs and expectations for a successful experience. These frameworks can be useful in planning to ensure a broad array of access and engagement opportunities. For example, creating experiences that support some visitors' need for a quiet, contemplative experience must be considered alongside other visitors' need for a more social learning experience. From sociology literature, *Audiences* by Abercrombie and Longhurst (1998) takes a broader view. Examining audiences of media, performances, and cultural opportunities, the authors describe a paradigm shift in general audience research similar to that already described in Section 2.2: a shift from "treating audiences as being addressed" to treating them as participants engaged in "identity development and the construction of self" (Abercrombie and Longhurst 1998, 36–37). Research studies are reframing our notion of audiences from passive consumers of stimuli to active participants in the performance. This and other audience research can deeply inform our thinking about and description of visitor perspectives.

Tier 2. Outputs

Outputs, the second tier in the hierarchy, represent one type of result. As used in the hierarchy, *outputs* refers to the initial tangible and quantifiable results of an educational effort, particularly those things that are measured in terms of volume of work accomplished, for example:

- the number of people who attend a particular program (i.e., participation)
- the cost per participant for developing and implementing a program (i.e., cost/participation ratio)

- the total number of programs or activities sponsored, delivered, or completed in any given period of time (i.e., program delivery or saturation)
- the number of publications or tangible products produced or distributed over space or time (i.e., saturation ratio)

Outputs are presented in the hierarchy at a low tier because they are a traditional measure of success and they are most easily determined through counts of people, programs, or participation. As the United Way publication (Hatry et al. 1996) suggests, although outputs have little inherent value, they remain important because they describe the reach into a particular target population and assist in describing how an organization will accomplish an intended result.

Tier 3. Outcomes

If outputs are a measure of the volume of work accomplished, then outcomes are the consequences of that work: the benefits derived by participants during or after their involvement with a program (Hatry et al. 1996). Michael Patton perhaps describes outcomes best by using an old adage: You can lead a horse to water but you can't make him drink.

> This familiar adage illuminates the challenge of committing to outcomes. The desired outcome is that the horse drinks the water. Longer-term outcomes are that the horse stays healthy and works effectively. But because staff know they can't make a horse drink water, they focus on the things they can control: leading the horse to water, making sure the tank is full, monitoring the quality of the water, and keeping the horse within drinking distance of the water. In short, they focus on the processes of water delivery rather than on the outcome of water drunk. . . . Funding is based on the number of horses led to water. Licenses are issued to individuals and programs that meet the qualifications for leading horses to water. Quality awards are made for improving the path to the water—and keeping the horse happy along the way. Whether the horse drinks the water gets lost in all the flurry of lead-to-water-ship. Most reporting systems . . . never quite get around to finding out whether the horse drank the water and stayed healthy. (Patton 1997, 157–58)

Outcomes, as shown in the hierarchy, are divided into three temporal phases: immediate, short-term, and long-term, with the lowest the most immediate to the actual visitor experience and the others progressively more distant from that particular experience.

Immediate Outcomes

An immediate outcome is the desired interaction expected during the real-time visitor experience, while the visitor is actually engaged with

the program or exhibit. Perry (2012) uses the term *engagements* to differentiate immediate outcomes and recognizes that these real-time interactions can be social, intellectual, emotional, or physical.

Short-Term Outcomes

Short-term outcomes are changes or transformations that might be expected of a visitor shortly after an engagement with an exhibit, program, or activity (for example, upon leaving the exhibit and up to several days later). These outcomes can include changes in awareness, interest, knowledge, attitudes, enjoyment, skills, and individual or social behaviors.

Long-Term Outcomes

Long-term outcomes are changes or transformations in visitors expected sometime after encounters with an exhibit, program, or activity (for example, weeks or months afterward). They typically involve changes in life conditions that may have been influenced by new awareness, interest, knowledge, attitudes, enjoyment, skills, and individual or social behaviors experienced during the original encounter. Due to the lapse in time, cause and effect for this type of outcome can be difficult to measure. Yet an institution that intentionally plans for progressive levels of outcomes demonstrates that it at least strives toward some ultimate impacts of its efforts. Existing research about engagement and learning in museum experiences is plentiful (see, for example, bibliographies collected in Screven 1999, and Wells and Smith 2000, and generally the journals *Visitor Studies Today!* and *Journal of Visitor Research*). It can be used to support and explain the nature and likelihood of particular outcomes.

For all types of outcomes (immediate, short-term, long-term), the hierarchy also addresses potential psychosocial domains (right-hand column). These domains, widely applied in educational psychology, are designated:

- cognitive (intellectual): what visitors think, question, and compare
- affective (emotional): how visitors feel inspired, excited, intimidated, frustrated, or awed; levels of enjoyment
- psychomotor (behavioral or physical): what visitors touch, feel, read, spend time doing; activities and skills
- social (interpersonal): what visitors talk about and share with their group

We realize that some outcomes—for example, changes in attitudes (Ajzen and Fishbein 1980), self-efficacy (Bandura 1986), or interest (Ainley, Hidi, and Berndorff 2002)—will involve hybrids of these domains. But, because extended discussion of psychosocial variables is beyond the scope of this book, we offer the four categories above as a helpful organizer when thinking about intended outcomes.

Although no one right formula exists for writing outcomes, nor is it the expectation that all interpretive plans or projects will include all types of outcomes, considering both time frame and learning domains can be useful when writing outcome statements. Planners should discuss thoroughly the intended outcomes for all domains at the immediate, short-term, and long-term levels during the planning process and modify them as appropriate for evaluation. The outcomes eventually included in the interpretive plan should be specific and measurable. We provide further guidance for developing outcomes in Section 4.3.

Tier 4. Impacts

Communities are increasingly examining their capabilities to provide quality lifelong learning experiences and public understanding of science and culture. The United Nations Educational, Scientific and Cultural Organization (UNESCO), for example, has identified lifetime education as one of its key issues for future education planning (UNESCO 2004). Also, the public understanding movement, started in the United Kingdom in 1985, focuses on public understanding of a number of disciplines. Museum professionals, as they take a broader interest in defining and demonstrating their programs' public value, are feeling pressure (e.g., from foundations, donors, political leaders) to evaluate programs in terms of societal contribution.

Marcella and her colleague Ross Loomis offer a "visitor opportunity system" that includes five categories of informal learning impacts including: psychological (e.g., improved literacy, personal development and growth), physiological (e.g., reduced stress), social (e.g., family solidarity, ethnic identity), economic (e.g., enhanced work productivity or local economic stability), and environmental (e.g., increased stewardship, caretaking or protection of objects or ideas) (Wells and Loomis 1998). These impacts constitute the top tier of the Outcomes Hierarchy. Impacts in this case describe collective results or effects; for example, how might what one visitor experiences in a museum, together with all of that person's other life experiences over time, impact his or her life? or how might what several visitors experience in museums collectively benefit a community or society at large in terms of literacy, social, or political engagement? In the article "Transforming Museums—To What End?" Randi Korn summarizes:

> The learning process begins with the staff clarifying their museum's intended impact in the context of answering the question "to what end?", realigning practices so they support the museum's intended impact and reflecting on practice and evaluation findings to improve practice, thereby moving the museum closer to achieving public value. (Korn 2008, 5–6)

Impacts are the most ticklish of all results to measure. Cause and effect are very difficult to track in most instances, due to temporal and

geographic challenges. Though difficult, measuring this level of impact is not impossible (see sidebar, Impacts). Unfortunately, there currently are few precedents; guidance is rare; and there is little funding, expertise, and institutional support for longitudinal research or repeated measure designs. There is also the question of whose job it is to design and conduct these types of studies. Often it is the academic sector (researchers in economics, psychology, sociology, leisure studies, and other social sciences) that has the interest in and expertise to design studies that report long-term impact or to commission retrospective research that looks at collective impact. Increasingly, evaluators and professionals in informal learning settings will need to conduct their own studies of the impacts of informal learning. This presents a compelling opportunity for creative partnerships.

Impacts

Example 1. An Accumulation of Outcomes

In *Their Own Voices: Museums and Communities Changing Lives* (Borun, Kelly, and Rudy 2011) the authors discuss the impact of a series of related programs offered by a group of museums in Philadelphia from 1992 through 2009. They interviewed participants who had been identified as fully engaged, looking for insight into what caused them to become so involved in these programs. The research team learned that the emergent impacts of these programs included the following:

- Families expanded their repertoire of family activities, including more visits to museums and more science-focused activities.
- Programs helped improve communication between parents and children.
- Involvement increased confidence in science abilities.
- Programs changed career aspirations of some of the children.
- Programs broke down barriers between members of different communities.
- Programs fostered multigenerational learning.

Example 2. The Power of Tess

In 1998 the California Science Center in Los Angeles opened its doors after a major renovation. Among the new exhibits was "Tess," a 50-foot animatronic body simulator. One desired outcome from this exhibit was that visitors, after exposure, would be able to define the concept of homeostasis. As explained by Falk and Dierking (2010), before the opening of the Tess exhibit, only 7 percent of the general public of Los Angeles could define *homeostasis*.

Tess turned out to be extremely popular and, after engaging with it, the majority of visitors could define the term when exiting the museum. Falk continues that "the ability to correctly explain this one scientific concept has increased nearly threefold in Los Angeles over the decade following the reopening of the Science Center" (Falk and Dierking 2010, 488).

Uses of the Outcomes Hierarchy

Although we originally developed the hierarchy simply to organize thinking about outcomes, it has evolved into a conceptual framework that has a number of other uses. First, the hierarchy is useful for planners for demonstrating how visitor perspectives can be conceptualized throughout the planning process, to show how educational impact can be constructed, and to anticipate how visitor studies might be employed. Furthermore, it can help build a shared vocabulary and a shared understanding about visitor experiences, whether for a single project or for an institution.

Second, the hierarchy can be useful for managers as a framework for communicating the big picture of audiences, outputs, visitor outcomes, and impacts to museum staff, project managers, evaluators, funders, and project stakeholders such as community leaders and politicians (Appendix A presents an example of how the Outcomes Hierarchy can be used as an executive summary of visitor perspectives).

Third, the hierarchy is useful for funders and others who evaluate planning and visitor studies proposals and reports. Seeing how an institution organizes data and information about visitors in general and how they anticipate building impact through outputs and outcomes, funders can weigh the strengths and weaknesses of a proposed project. Alternatively, funders can point to the hierarchy to encourage the institution to focus its attention on the various components, to describe audiences carefully, and to articulate the anticipated outputs, outcomes, and impacts of a project.

Fourth, the hierarchy is useful for evaluators and audience researchers in challenging current thinking about visitor experiences and lifelong learning and meaning making, and to stimulate discussion about creative ways to comprehensively plan and evaluate these experiences. Just as GPRA challenged the industry to move from counting activities and visitors to more fully defining and measuring outcomes, the hierarchy challenges museum professionals—particularly planners, designers, educators, and evaluators—to differentiate and order outcomes that build toward impact, and to better orchestrate the measurement of those anticipated outcomes.

Finally, the hierarchy is a succinct way for teachers and trainers to communicate with students and trainees about planning for intended visitor outcomes and evaluating the results of visitor experiences. Toward that end, the hierarchy is useful for discussing the importance and cumulative nature of outcomes.

The primary contribution of the hierarchy lies in its usefulness as a touchstone for thinking about and discussing visitor perspectives throughout the process of planning. Museum planners must apply intentional effort and deliberation if they are to fully integrate visitor perspectives into their plans; we offer the hierarchy as assistance in this effort. Our next chapters present the concepts of integration more fully, with particular focus on the process of developing outcomes. We provide a number of examples from existing master and project plans.

4.3. DEVELOPING OUTCOMES AND IMPACTS

Developing projected outcomes and impacts is important in interpretive planning as part of ensuring that visitor perspectives are considered throughout the planning process. Although there is general agreement about the importance of outcomes, there is far less agreement about how best to write outcome statements. We suggest that outcomes and impacts are related but that, as already noted, they differ in scale. Outcomes are benefits or change to individuals or populations during or after program or exhibit engagement that may relate to knowledge, attitudes, or behavior. Impacts are broader, or more collective, benefits or change typically expressed at a community or societal level. Societal impacts relate to the needs of the community (or society at large)[8] and the museum's role in helping to meet those needs. Impacts can be more difficult to conceptualize and measure than outcomes and often require deliberate, rigorous research and funding to evaluate.

The development and evaluation of measurable outcomes and impacts generally results in findings that are useful to the organization on many levels. Evaluation results support program improvement, strengthen communication with funders and media, and demonstrate to governing boards that results are tangible. The deepest value of the exercise, however, lies in the planning of outcomes. The process of building shared vocabularies, deliberating about purpose, and constructing outcomes as a team enhances staff relationships and product development, while also supporting planning decisions. In the act of articulating measurable outcomes, the planning team coordinates its efforts and articulates the purpose of the project from the visitor perspective. In addition, well-written

outcome statements are tremendously useful to evaluators in planning and implementing evaluation, and thus, whenever possible, an evaluator should participate in the development of outcome statements.

Few organizations have the resources necessary to measure all the outcomes of all their offerings. Many are reluctant to formulate desired outcomes or support even basic levels of outcome measurement, as they see the effort as drawing resources away from doing the fundamental work of the organization. This may be because definitions of and guidance about outcomes are varied, but also because the museum management field as a whole is still trying to understand the value of outcomes and the requisite visitor studies that must accompany them.

Desired outcomes that are projected in planning stages will be *intended* outcomes. Museum programs or projects will also realize among its results some *unintended* outcomes. Whether these work in favor of or against project goals, noting unintended outcomes provides valuable information. It is important, therefore, that an evaluation plan not be so focused on measuring the presence and strength of articulated outcomes that crucial unintended outcomes are missed or ignored.

When developing desired outcome statements, sometimes called *learning objectives*, it is important to consider the learner's perspective, starting with the desired result and using active verbs that describe effects to create a statement that expresses the desired result. How do you want your visitors or audience to be affected or changed—cognitively, affectively, physically, or socially—as a consequence of the experience you provide? Outcome statements describe intended changes in the visitor; they typically begin with such wording as "after involvement with [the learning activity], the participant will . . ." and move on to describe a measurable desired result and a degree of intended performance. There is a robust and readily available literature about writing outcomes on the Internet that goes beyond what we present here. What follows are some tips for creating useful outcome statements.

One of the clearest formats for formulating intended outcomes and impacts is the ABC method. ABC stands for antecedent (the learning activity), behavior (the skill, knowledge, or affect being demonstrated), and criterion (the degree of acceptable performance). If the goal of a traveling exhibit is to increase awareness and empathy for the plight of elephants in Kenya because of the ivory trade, an example of a *short-term outcome statement* (both cognitive and affective) using this method might read:

(A) After visiting the exhibit about elephants, visitors or visitor groups will
(B) describe their anguish by stating
(C) three salient facts about the ivory trade gleaned from the exhibit.

If a museum's master interpretive plan includes a goal to work with community groups to reduce negative impact on the environment, their *impact statement* might read:

(A) After participating in museum programs, adults will
(B) join in community efforts
(C) to reduce the volume of recyclables going to landfills.

Another method, suggested by the W.K. Kellogg Foundation and others, called SMART, represents five criteria for a complete outcome:

Specific (to a target population or materials or media presented)
Measurable (quantifiable)
Achievable (realistic)
Results-oriented (some say, Relevant)
Time-specific (has deadlines)

The SMART method requires that indicators and deadlines be included. This level of detail is not necessarily needed or useful at certain stages of planning, particularly for a master interpretive plan, where the scale of the plan is broad and thus planning for recommended products and services may still be general. Once planners have completed additional project planning for the specific exhibit or program, then very specific (measurable) outcomes may be developed, particularly if any visitor studies are also planned.

An important criterion for writing good outcome statements is that the results proposed must be measurable. Weak statements are frequently the result of using verbs that are too broad or vague to describe the change you intend to facilitate. When statements include abstract concepts, clarity is muddied. Consider the difficulty of measuring the effects or conditions denoted by the words in the following list; to be useful, each would need further clarification.

Examples of broad or vague verbs:

Know	Enhance	Enjoy
Understand	Improve	Discover
Appreciate	Increase	Internalize
Ponder	Be exposed to	Learn about
Experience	Alter	Become familiar with
Feel comfortable	Grasp the significance of	
See		

Vaguely written outcome statements using select words from the list above might read as follows (explanations are included in parentheses):

- Visitors will understand the concept of photosynthesis. (Does *understand* mean they will be able to define it, describe its principles, create an experiment that tests it, or some other intention?)
- Families will discover that they perceive colors differently. (Does *discover* mean that families will talk about their favorite colors? Will they experiment with different color palettes? What might they do, think, feel, or talk about that leads to this realization?)
- Visitors will be exposed to the work of artists called "Cubists." (*Be exposed to* indicates what visitors will see, but not how they will engage or what they will do, think, or feel as a result.)

Additional examples of vaguely written impact statements include:

- Participants will be exposed to cultural amenities of their community. (What does exposure look like, and how much exposure constitutes effectiveness?)
- Members of our community will improve their appreciation of artistic qualities in local architecture. (What will improved appreciation look like, and how much or what kind of improvement is desired?)
- Visitors will become familiar with community organizations involved in historic preservation. (Becoming familiar with something does not necessarily mean there will be any change in the visitor or in the community's eventual efforts to improve historic preservation. It should be made clear what is expected of the visitor who gains this familiarity. Will he or she make a donation, volunteer for board service, join an organization?)

By contrast, using more specific active verbs will help create better outcome statements and more measurable outcomes. Action verbs like the following ones are preferable in that the learner must perform the action, thus showing evidence of engagement or learning.

Examples of action verbs:

Define	Recite
Classify	Argue
Compute	Arrange
Compare	Display

Bloom's Taxonomy is a useful guide for constructing clear and measurable outcomes and has the added benefit of connecting easily to formal education assessment when appropriate. Benjamin Bloom was a professor of education from 1943 to 1970 at the University of Chicago, and in 1956 he chaired a group of educational psychologists to develop

a classification for levels of intellectual behavior important in learning. Known as Bloom's Taxonomy, it is now widely applied in formal education for planning and assessing student achievement, but it is also useful for conceptualizing informal learning activities. Following the development of his original taxonomy, Bloom and others subsequently developed others for other domains. Common taxonomies now include the cognitive, affective, and psychomotor domains, each of which provides a hierarchy of concept complexity. For the purposes of this book, we have also added the social domain as developed by Leinhardt and Knutson (2004) since museumgoing, by its very nature, is a social experience for many people.

The value of the four taxonomies presented in Tables 4.1–4.4 for our discussion is that they help segregate outcomes by level of achievement and they provide active verbs to use in writing outcome statements. When phrasing desired outcomes, planners should target multiple levels of the hierarchical categories in order to reach multiple levels of learning.

The cognitive domain, initially conceived by Bloom (1956) and later adapted by Anderson and Krathwohl (2001), involves knowledge or cognition and the development of intellectual skills. This includes recognition, recall, and comprehension of specific facts, procedural patterns, and concepts that factor in the development of cognition, such as interest. Bloom's Taxonomy (Table 4.1) proposes six hierarchical categories listed from simple (top) to complex (bottom) for the cognitive domain. Bloom arranges them in increasing degrees of difficulty, suggesting that those in the first tier must be mastered before those in the next are possible. If the purpose of a learning activity is to stimulate the intellect and expand knowledge, then related outcome statements should be developed using this hierarchy.

Likewise, an affective domain hierarchy (Krathwohl, Bloom, and Masia 1964), published a few years after Bloom's original cognitive domain hierarchy, addresses the affective aspects of learning that involve feelings and emotions, such as appreciation, enthusiasm, enjoyment, awe, and anguish. If the purpose of a learning activity is to stimulate emotions or feelings, then related outcome statements should be developed using this hierarchy. The affective domain hierarchy (Table 4.2) is arranged in five major categories, from simple (top) to complex (bottom).

The growing body of visitor studies research related to affect in museum experiences, showing that affect is a powerful component of learning (e.g., Kort, Reilly, and Picard 2001; Myers, Saunders, and Birjulin 2004; Roberts 1991; Webb 1996) may challenge this 1964 hierarchy; you may find it useful to consult more recent visitor research when developing affective outcome statements.

The psychomotor domain emphasizes behavior and the use of physical skills. Development of these skills requires practice and is measured

Table 4.1 Cognitive (Intellectual) Domain Hierarchy (compiled from Bloom 1956, and Anderson and Krathwohl 2001)

Learner's Behavior	Action Verbs
Knowledge: Retrieves relevant knowledge from long-term memory. Involves processes of recognizing and recalling.	define, describe, identify, label, list, match, name, outline, recall, recognize, reproduce, select, state
Comprehension: Constructs meaning from instructional messages, including oral, written, and graphic communication.	classify, cite, estimate, explain, extend, generalize, infer, interpret, paraphrase, predict, rewrite in own words, summarize
Application: Carries out or uses a procedure in a given situation.	apply, compute, construct, demonstrate, manipulate, modify, operate, predict, prepare, produce, show, solve, use
Analysis: Separates material or concepts into component parts and determines how the parts relate to one another and to an overall structure or purpose.	analyze, compare, diagram, deconstruct, differentiate, discriminate, distinguish, identify, illustrate, infer
Evaluation: Makes judgments about the value of ideas or materials based on criteria and standards. (Some equate this to critical thinking.)	appraise, conclude, contrast, critique, discriminate, evaluate, explain, interpret, justify
Creation: Puts elements together to form a coherent or functional whole; reorganizes elements into a new pattern or structure. (Some equate this to creative thinking.)	combine, compile, compose, construct, create, devise, design, generate, modify, plan, rearrange, reconstruct, reorganize, revise, rewrite

in terms of coordination, precision, speed, distance, procedures, or techniques in execution. According to Dave (1970), the five categories presented in Table 4.3 provide a psychomotor hierarchy comparable to those given here for cognition and affect. Again, the levels are listed from simple (top) to complex (bottom).

Leinhardt and Knutson (2004) defined a social domain hierarchy for social engagement in the manner of Bloom's Taxonomy (Table 4.4). Examples of social engagement might include conversation, discussion with others, call overs (when a person calls over another to show or tell them something), show and tell, collaboration, and deliberation. Several visitor studies professionals have studied social interactions in museums,

Table 4.2 Affective (Emotional) Domain Hierarchy (compiled from Krathwohl, Bloom, and Masia 1964)

Learner's Behavior	Action Verbs
Receiving Phenomena: Emphasis is on awareness, willingness to hear, selected attention. The attention may be passive.	ask, acknowledge, follow, locate, select, retain, respond, process
Responding to Phenomena: Involves active participation on the part of the learner who attends and reacts to a particular phenomenon. Learner is willing to respond, or shows emotion in responding. The reaction may be passive.	answer, assist, aid, comply, conform, discuss, greet, help, label, perform, practice, present, read, recite, report, select, tell, write; show respect, disgust, disappointment, joy, curiosity
Valuing: Demonstrates the worth or value a person attaches to a particular object, phenomenon, or behavior. The range is from simple acceptance to commitment based on the internalization of values. Clues to these values are expressed in the learner's overt behavior.	argue, complete, commit to, convince others, differentiate, explain, follow, initiate, invite, join, justify, propose, protest, read, report, select, share, study, volunteer, practice; show pleasure, acceptance, sorrow, anguish
Organizing Values: Involves contrasting different values, resolving conflicts between them, and/or creating a unique value system. The emphasis is on comparing, relating, and synthesizing values. Putting together different values, information, and ideas and accommodate within his or her own schema.	alter, arrange, combine, compare, complete, defend, explain, formulate, generalize, identify, integrate, modify, order, organize, prepare, synthesize, react, balance, manipulate; show passion, tolerance/intolerance
Internalizing Values: Has a value system that controls one's behavior. The behavior is pervasive, consistent, predictable, and most importantly, characteristic of the learner. Learner holds a particular value or belief that exerts itself in his or her behavior so it is a characteristic.	act, discriminate, display, influence, listen, modify, perform, practice, propose, qualify, question, revise, solve, verify, obsess, judge, rejoice

particularly conversations among social groups and family visitors (Borun and Chambers 2000; Crowley 2000; Perry 1993). We encourage you to consult this growing body of work when writing social outcome statements. There are four levels in this social domain hierarchy, again arrayed in order of increased complexity from top to bottom.

The creation of specific statements about measurable outcomes is an imperfect science at best. One of its most valuable results is that it stimulates discussion and thinking among planning team members about visitors

Table 4.3 Psychomotor (Behavioral) Domain Hierarchy (compiled from Dave 1970)

Learner's Behavior	Action Verbs
Imitation: Observes and patterns behavior after someone else. Performance may be of low quality.	trace, copy, follow, imitate, reproduce, locate, obtain, hear, smell, taste, feel
Manipulation: Performs skill according to instruction rather than observation.	assemble, adjust, build, calibrate, connect, focus, play (as in music or game), thread
Developing Precision: Reproduces a skill with accuracy, proportion, and exactness; usually performed independently of original source.	assemble, set up, manipulate, calibrate, calculate, mix
Articulation: Combines more than one skill in a sequence, achieving harmony and internal consistency.	manipulate, coordinate, combine, regulate, integrate, standardize, shape, recreate
Naturalization: Has a high level of performance. Performance becomes automatic. Completes one or more skills with ease. Creativity is based on highly developed skills.	create, formulate, design, invent, construct, develop

Table 4.4 Social (Interpersonal) Domain Hierarchy (compiled from Leinhardt and Knutson 2004)

Learner's Behavior	Action Verbs
Listing: Identifies features in the environment, descriptive talk.	talk about, describe, read aloud, point, call over
Analysis: Tries to figure out how features of an environment work.	talk about, describe, work in a group, have a conversation, deliberate, try an activity
Synthesis: Uses features outside of the immediate environment and merges that information with features of the current environment.	realize and point out or describe connections, discuss connections, deliberate about testing or trying in a new way
Explanation: Uses casual examples or personal experience to understand the current environment; explains to others.	explain to others, teach, facilitate, use examples or personal experience to explain to others, exemplify

and about desired effects. Although guidance about writing outcomes can seem overwhelming, no one really fails at it. As we have discussed, there are some ways of expressing projected outcomes that are better than others; the only real failure is not thinking about the desired effects on visitors of their experiences, and not recording that thinking for discussion and eventual evaluation. If outcome statements turn out awkward or vague, this can be addressed with an evaluator. In any case, the act of discussing and composing outcomes affirms that the team has considered the visitor perspective.

One additional factor that can complicate outcome writing is a confusion between visitor outcomes and institutional goals. The latter are always written from an institutional perspective, whereas the former are written from the visitor perspective. We offer some examples of outcome and impact statements paired with respective management goals. Depending on the institution or project, one goal may have more than one outcome or impact statement.

> Planning goal: To play a more integrated role in tourism by developing a new community-specific permanent exhibition in the Sunshine Gallery. Outcome: Visitors will visit other historic and cultural features of the community as a result of linkages made in the exhibition.

> Program goal: To establish a community-wide Green City program that includes museum activities.
> Long-term outcome: After participating in the Green City program, adult participants will describe at least four steps for decreasing one's environmental footprint, and will implement at least two of those processes at home in the next three months.

> Planning goal: To enhance the public's appreciation of local architecture by working with historical groups, architects, and others who have an interest in architecture.
> Impact: Community leaders (e.g., the Downtown Business Association, Visitor and Convention Bureau) will identify architecturally important buildings and work with the museum to create a self-guided architectural tour for tourists, students, and the community.

Writing outcomes is an iterative process and, as with other skills, the ability to formulate clear, measurable, and compelling desired outcome and impact statements improves with practice. With the increasing emphasis on public value and intentionality in museum practice, institutions are shifting from describing to defining (with evidence) the importance of a museum's role in its community. Including intended outcomes as common practice in planning and decision making, museums can more clearly communicate past performance to funders, staff, and community, and more deliberately plan future work.

Chapter 5

Integrating Visitor Perspectives in Master Interpretive Planning

5.1. Introduction

Like a strategic plan, an institution-wide master interpretive plan paints a general and strategic picture of interpretive and educational intentions for the entire institution within a broad context. Planning at this scale addresses strategic institutional visioning for visitor experiences and engagement and articulates the organization's role in the community.

Master Interpretive Plan

Institution-Wide Interpretive Plan, Long-Range Interpretive Plan, Comprehensive Interpretive Plan, Interpretive Strategy, Interpretive Framework, Community Connections Plan, Museum-Wide Exhibition Master Plan

There is no "right" size for a master interpretive plan. Some organizations prefer a thorough and detailed approach; others prefer a more streamlined document. Master plans can range from ten to a hundred or more pages depending on the size of the organization and its intent for interpretation and education. Furthermore, there is no perfect recipe for a plan, although there are important elements and decisions that should be considered in all interpretive planning. Each plan is unique and should be developed in a way that is useful and personalized for a particular museum. In the end, a master interpretive plan should communicate clearly to staff, community leaders, funders, other stakeholders, and contractors a deliberate intention for visitor experiences with the museum, and assist these people in understanding their particular roles in the larger context of the organization.

In this chapter we outline elements that we recommend including in a master interpretive plan. For each section of a plan, we suggest several driving questions, provide details of the types of information that should be gathered, and offer suggestions for integrating visitor perspectives. Consistent with the focus of this book, we spotlight portions of the discussion that suggest ways of integrating visitor perspectives in master planning by a small triangle icon, which points to an opportunity to enlist the Outcomes Hierarchy as a touchstone for thinking about visitors. Finally, we include examples from actual master interpretive plans (with permission) to illustrate what some institutions have included in their master plans. In most cases, the embedded examples are not complete plans but are excerpts from the original plans; thus we are able to provide concise examples of the various components of a master interpretive plan. As needed, we have presented a few explanatory comments with these examples, which appear in italics; format and punctuation in the excerpts follow their originals.

The primary example used in this chapter comes from the Coastal Maine Botanical Gardens in Boothbay, Maine. Their Education and Interpretive Master Plan, completed in 2008, was the first interpretive plan for a 248-acre botanical garden founded in 1991. At the time the plan was developed, the Gardens had recently completed an initial site design and development. The table of contents that outlines the complete content of this master interpretive plan is included in Appendix B.

Depending on the institution, the purpose of the plan, and the intended uses of the plan, the sections included and the length of those sections may vary significantly. As we have already indicated, there are many right ways to plan. The best interpretive plan is one that is useful for guiding decisions about and subsequent development of engaging visitor experiences with the particular institution.

5.2. SITUATION AND NEED

As we have described briefly in Chapter 3, the initial stages of master interpretive planning should address questions such as: Who are we? What is our current situation? Why is interpretation and education important for our institution? Why is our institution and its interpretative and educational programs important to our community? Where are we in our growth and maturity with regard to education and interpretation? This part of the plan should provide the reader with sufficient background and context for the current planning effort. More specifically, this section of the plan might include:

- A description of the institution in terms of name, geographic location, and size (which can be described in square feet,

visitation numbers, budget, or whatever metrics best convey the size of the institution for the readers of the plan).

- A brief background or history of the institution including vision, mission, organizational structure, and relevant governance.
- A description of what makes the institution and its collection special, unique, or important. Does the museum have the only, or the largest, or the most valuable fifteenth-century textile collection? Is it the only institution of its kind within a 100-mile radius that teaches space science? Does the collection tell a unique story in history? What significant role does the museum play in the learning landscape of the community or region? This significance will be elaborated more fully in the plan's inventory (see Section 5.4), but a brief statement about the unique qualities of the institution is highly appropriate in the introductory part of the plan.
- A carefully written description of the need for the plan, with rationale that supports that need. Why is this planning process being initiated for this institution at this particular time? Is this the first master interpretive plan for this museum, or has the institution accomplished the goals of a previous plan and now needs to outline a strategy for the next planning horizon? Is there an unusual financial, political, economic, or educational opportunity that stimulated this process?

Situation and Need for the Plan

Excerpted from the Education and Interpretive Master Plan for Coastal Maine Botanical Gardens (CMBG 2008)

Overview of the Organization and the Site

Founded in 1991, CMBG aims to be a world-class facility for nature education, gardening and horticulture, and economic stimulation. CMBG is a 248-acre property located along the central coast of Maine near Boothbay. The site contains nearly ten acres of new ornamental gardens on the main campus, two miles of woodland and shore land trails, and a number of other gardens, trails, and facilities.

The organization, a robust 501(c)(3) nonprofit, employs 12 full-time staff and 5 seasonal employees, but also manages 40 docents (education volunteers), more than 350 site volunteers, and has more than 2,500 active members. Guided by a mission to "protect, preserve, and enhance the botanical heritage of coastal Maine for people of all ages through horticulture, education, and research," CMBG's current strategic goals are to:

a. Create a world-class botanical garden with formal and informal ornamental gardens that educate people about how to select and grow plants hardy to coastal Maine.
b. Promote environmentally responsible gardening and ecological restoration practices for Maine home gardens and natural landscapes through educational and research programs.
c. Educate visitors of all ages on the botanical heritage of Maine.
d. Train amateur gardeners and future horticulturists by offering education programs and internships.

Need for and Purpose of this Plan

Each of the Gardens' strategic goals mandates education. In addition, the Gardens' Strategic Plan contains an important management goal and two related objectives relevant to education.

[From strategic plan:] Goal #2: To establish educational and research programs that promote the art and science of horticulture, the understanding and appreciation of Maine's botanical heritage, and environmental stewardship.

Objective a: Establish a comprehensive education program that provides lifelong learning opportunities for all ages in horticulture and environmental sciences.

Objective b: Create informal learning experiences for garden visitors with interpretive information, displays, and programs that expand visitor knowledge, interest, and passion.

Educational efforts began in earnest during the 2007 season, but this will be the first deliberate plan for the Gardens to provide continuity over time and to guide disciplined and strategic future development of interpretive and educational efforts for the Gardens.

In the first pages of a master interpretive plan, it should be made clear that the plan is grounded in the institution's vision, mission, and core values or guiding principles. This information is easily extracted from the institution's strategic plan. In the Botanical Gardens example above, a link was made to the Gardens' strategic plan by reiterating a management goal and two related objectives relevant to interpretation and education at this Garden.

To integrate visitor perspectives at this stage, planners may also address additional questions concerning relationships with the community, such as: What is our current role in the community? What is our desired relationship with the community? What impact do we want our institution to have on the community? What are the intended impacts of

individuals' experiences in and with our museum? Engaging the community in these discussions is always useful for developing intended impacts that relate to the needs of the museum and community. As stated by Anderson, Storksdieck, and Spock,

> The value and importance of understanding the long-term impact of our museums on visitors should not be underestimated. . . . The long-term impacts of museums should be considered not only at the level of the visitor but also at the level of the communities museums serve. Understanding the long-term impact of museums enables a better understanding of how to serve and enrich communities, of which museums are a part. (Anderson et al. 2007, 197)

Statements about desired impact at the master planning scale are somewhat sweeping in nature, but they are essential for eventually tying the results of the plan back to its intended goals and the museum's mission. As the master interpretive plan is a guiding document for all of the museum's programs and exhibitions, planning at this scale aligns well with impacts and long-term outcomes (see Chapter 4, tiers 3 and 4 of the Outcomes Hierarchy). Impact statements suggest what difference the overall suite of educational and interpretive offerings will make in the life of the community. Individual project interpretive plans will then address shorter-term outcomes that, when taken together across the suite of offerings, should support the desired impacts outlined in the master plan.

Goals and Impacts

Excerpted from the Detroit Institute of Arts (DIA) "Revitalize, Reinterpret, Reinstall" Reinstallation Project Plan, 2002

Between 2002 and 2006, in an effort to become more visitor-centric, the DIA embarked on a major reinstallation effort that involved reframing visitor experiences with that institution. The following excerpt from their planning effort illustrates well the inclusion of goals and impacts at the outset of their planning effort.

Art and museum experience

Museum visitors arrive with a broad range of experience and knowledge about art and what the museum offers. There are so-called "novice" and "expert" visitors, and everything in between. The interpretive plan must account for the fact that this range of visitors seeks very different kinds of experiences when they visit the museum. The interpretive plan should endeavor to provide interpretive experiences for all visitors. Some considerations are:

- Clear and consistent orientation to gallery spaces
- Cultural and art historical information
- Introductions to ways of looking at art
- Use of full range of interpretive media for different learning styles
- Validation of emotional responses or experiences that are personally meaningful

Goals

The DIA interpretive strategy requires concrete goals and outcomes; something that can be measured to determine whether or not our efforts are successful. For the reinstallation, the DIA will focus upon two interrelated goals: (1) provide satisfying and fulfilling experiences, and (2) stimulate learning. These goals recognize that successful museum experiences must combine both satisfying experiences and learning for the widest array of audiences.

The plan goes on to describe what satisfying and fulfilling visitor experience mean for this institution.

Because a master interpretive plan is a "strategic sieve" through which all decisions about interpretive and educational initiatives will be sifted, introductory content of the plan should outline the proposed planning process, identify the planning team, discuss the planning timeframe or horizon (see sidebar, A Note about Planning Horizons) and describe any other special considerations (financial, political, geographic, regulatory) related to the planning process. Planning considerations might include whether or not there are any (a) political or economic limitations to this planning effort, (b) planning assumptions that need to be acknowledged, or (c) policies or museum regulations or guidelines that might influence the planning effort. Providing other introductory information may be useful for eventual readers and users of the plan—for example, terms and definitions, how the plan is organized, and audiences for the plan.

Planning Considerations

Excerpted from the Education and Interpretive Master Plan for Coastal Maine Botanical Gardens (CMBG 2008)

The following planning considerations are acknowledged for this planning effort. Interpretive and educational initiatives (I/E) recommended in this plan will:

a. Complement the overall CMBG vision and the aesthetic of individual garden units as guided by the Master Site Plan,
b. Complement the initial I/E efforts developed thus far,
c. Be thematic and consistent with compelling stories developed for the Gardens to date,
d. To the degree possible, consider and maximize accessibility in terms of mobility and sensory capabilities, and
e. Be reasonable and sustainable in terms of cost, time, effort, and the environment.

This level of detail in a master interpretive plan might seem superfluous; some might say: "We already know who we are; we have a strategic plan." However, for at least two reasons, some detail about the institution is desirable. First, many readers or users of the plan may be outside the circle of museum staff and not aware of details about the institution; for example, funders, community leaders, and possible contractors. A certain level of background information is useful to ensure consistency of awareness across readers and users. Second, depending on the desired horizon for the plan, individual staff or the organization of staff may change within that horizon. Providing background and current situation information about the museum ensures accountability for new players or new politics. The ideas in the plan may change, but new players will have at hand the initial assumptions of the planning process if the game changes mid-course.

A Note about Planning Horizons for Master Interpretive Plans

A master interpretive plan typically is written for a planning horizon of five to seven years, and sometimes even ten years. Depending on the needs of the institution, the planning horizon can be flexible in order to be responsive to new information, changing conditions, or unexpected funding or visitor opportunities. In addition, new and rapidly changing technologies, as well as more and better research about informal learning, may also influence the choice of time frame. A planning horizon should be set far enough out so that the plan provides strategic guidance over the long term, but short enough that it remains dynamic and useful in the short term.

Some institutions find it helpful also to develop annual work plans—yearly to-do lists based on the overall, broad-horizon strategic guidance

provided by the master plan. In this way, the institution can revisit the plan annually to determine which alternatives and actions are relevant and timely for the current situation. Annual work plans allow museums to be nimble and current in developing interpretation, while the master plan provides a strategic touchstone for optimizing future interpretive choices. The annual plans become addenda to the master plan and serve as an administrative record of accomplishments over the course of the plan. Ideally, there is a clear and seamless connection between the master plan and the work accomplished annually toward its full implementation. Thus, the annual work plans, if written to reflect the goals of the master plan, also serve as evidence of progress.

5.3. Purpose and Goals

If the background and current situation sections of the plan describe the institution and acknowledge the need for the plan, the next section answers the question: What do we hope to accomplish by planning for interpretation in our museum and in our community? In a collections-based institution, the master interpretive plan and the collections plan should together describe the overall content goals for the organization, and be strongly tied to the institution's strategic plan.

A museum that has never completed a master interpretive plan might state its overall goal as something like: to organize and establish a strategic and proactive program of interpretive exhibits and programs for visitor experiences with our institution. Goals will of course be worded differently depending on the size and nature of the museum. We offer the Botanical Gardens plan as one example.

Purpose and Goals

Excerpted from the Education and Interpretive Master Plan for Coastal Maine Botanical Gardens (CMBG 2008)

The ultimate purpose of this plan is to facilitate satisfying and meaningful visitor experiences at Coastal Maine Botanical Gardens. . . . Specifically, the goals of the plan are to:

- Inform and guide decision-making regarding interpretive and educational efforts for the Gardens—both personal and non-personal [an appendix was provided for reference],
- Define desired visitor experiences, formal and informal, with the Gardens (on-site, electronic, and outreach),

- Provide specific recommendations for interpretive and education programs, products, and services related to the Gardens' mission,
- Suggest ways to build capacity among staff for long-term sustainability of all interpretive and educational efforts.

Because CMBG is still heavily involved in finalizing site development, the planning horizon for this plan is approximately five years (2008–2012).

For a museum with an existing interpretive program, overall goals might include updating, upgrading, or otherwise reframing the interpretation or education programs and media for the museum, cultivating new audiences, stabilizing funding for general operations, or pursuing funding for new significant initiatives. For each general goal there may be one or more subgoals (or objectives) needed for elaboration. For example:

Goal: To build financial stability by increasing attendance and maximizing revenue-generating programs.

- Objective A: Increase new visitor attendance by x% each year for the next three years.
- Objective B: Review pricing policies to determine the optimal balance of opportunities for increasing revenue and increasing access (non-revenue-generating).

Although goals are always worded from the institution's perspective, some goals in a master interpretive plan may be directed at visitor experiences with the institution. For example:

Goal: To increase adult engagement with the museum.

- Objective A: Develop one new adult-focused program each year for the next three years.
- Objective B: Engage community adults in assessing current museum programs for relevancy for and engagement by adult visitors.

These are planning goals and objectives written from the institution's perspective; they are not desired visitor outcomes, which would be written from the visitor's perspective.

5.4. INVENTORY

The inventory stage of a master plan asks, what do we have and what do we know? The answer will have two parts. *Supply inventory*

addresses what we know about our available goods and services. As used in this context, *supply* refers to what currently exists within the museum and its purview—in terms of collections, staffing, dollars, materials, other plans and policies, and exhibits and programs—that may influence museum decision making about future exhibitions, educational programs, or interpretive media. *Demand inventory* addresses what we know about our audiences and their demand for those goods and services. In this context, *demand* refers to what we know currently (and what can we learn) about who wants our goods and services and why. This speaks to past, present, and possible future audiences and visitors.

Inventorying Supply

As you inventory supply, we recommend considering at least the following goods and services of your institution:

- The collection: What is the scope and nature of the collection? What is unique about it? How is it organized (in general terms, with possible reference to the collections plan)? What items or ideas rooted in the collection draw people to this museum or have education potential?
- Existing plans or documents: Are there other plans or documents that support or complement this planning effort? Is there documentation from other similar museums or organizations, or other sources of literature that might inform the current planning effort? How might this master plan integrate with other existing planning efforts of the institution? (Consult the list of museum plans in Section 3.2.)
- Existing staffing: What is the current staffing situation related to visitor experiences within the museum, including education staff, curatorial staff, design staff, in-house fabrication expertise and capabilities, customer service staff (admissions, security, information, coat check), website and IT support? As Weil (2000) asserts, education is central to a museum's purpose, and so most staff have a stake in a master plan for interpretation and education to one degree or another. Thus an organizational chart is useful to show relationships among departments and staff, especially as stakeholders outside the institution may also use this plan.
- Current interpretive exhibits or programming: What current interpretive projects are we spending time, money, and staff

on? What type of on-site, outreach, and web interpretation exists currently? What is our current strategy for orienting visitors?

- Library and research resources and education supplies and materials: What educational materials and resources (library, printed, web) do we have that support our current programming? What supplies are available to our educators? What do we have currently in terms of facilities, equipment, and resources that support visitor experiences?
- Existing evaluation or visitor studies: Do we know if our current initiatives are working? What types of visitor studies or evaluation efforts do we currently employ?
- Current budget and funding: What level of financial support is currently allocated for the museum's educational and interpretive efforts? How is funding for educational initiatives typically secured? What barriers to securing funding currently exist?

Remember that the answers to these questions are about what *currently exists*; not about what might be nice to have someday. That comes later.

Inventorying Demand

Proceeding through an inventory of demand helps museums match the needs of their communities with the assets and capabilities of the institution. We recommend using the Outcomes Hierarchy here for stimulating discussion and shaping decisions about what types of information are most helpful for describing current and potential visitors. In some cases, the input of an evaluator or visitor studies specialist may be useful when completing a demand inventory.

Information gathered for demand inventory can be both demographic and psychographic in nature (see tier 1 of the Outcomes Hierarchy, Figure 4.1, and discussion in Section 4.2). As we have already noted in Chapter 4, both primary and secondary sources can provide useful demand data and information. The museum marketing or membership department may have collected visitor data that is useful for planning, though in many cases it does not provide enough information to fully understand demand. Planners may wish to pursue more thorough audience analysis and demand inventory, which might involve interviewing visitors or hosting them (including potential visitors) in group discussions. They might also include researching the past, present, and expected future visitation for the museum, or shaping an even more robust context for demand by, for example, tapping secondary data sources available for the local community or region

(e.g., tourism, leisure, and recreation data). A demand inventory should consider both current visitors (current demand) and potential visitors (unmet demand).

Occasionally, institutions consider audience (demand) analysis such a significant part of planning that they prefer to address it as a discrete project. Such was the case when Canada's Royal British Columbia Museum in Victoria conducted a demand inventory and analysis as a separate process within a larger interpretive planning effort that eventually became a visitor experience master plan entitled "A Vision for the Visitor Experience" (RBCM 2008). Similarly, the Awbury Arboretum near Philadelphia conducted an audience analysis prior to their anticipated master interpretive planning project (Wells 2006).

We present here a sampling of questions to guide research and discussion about demand.

- Who is currently visiting the museum? Why are they coming? What do they expect here?
- Has visitation changed over time? What past trends should we consider? What future trends do we anticipate?
- What issues might influence future visitation?
- Are there target audiences that are not currently visiting? Why not? What are the major barriers for these people or audience segments?
- Is there any recent research that examines visitor experiences (including outcomes and impacts) similar to those we are trying to create?
- What reports, data, or information is currently available that will suggest who are potential visitors to this museum?
- Who else has a stake in the museum and its mission (e.g., partners, funders, donors, community leaders)? What expectations do they have for a relationship with the museum?

 It is essential that the planning team consider visitor perspectives, especially in institutions that strive to become more visitor-centric. They might listen to audience voices at this stage (see sidebar, Visitors . . .), which might involve a focused conversation among members of the team to discuss potential users, underserved users, and type and level of use by certain audience groups; or it might require a more substantial work session to discuss the implications of all available audience data and information once it is captured. In this process of demand inventory and analysis, it may be useful to collaborate with social scientists or visitor studies specialists.

> **Visitors. . . . They can be helpful in planning**
>
> Being visitor-centric and considering visitor perspectives in interpretive planning is not the same as integrating visitor studies or evaluations into museum practice, although they are often related. Reviewing visitor research as part of the audience inventory and analysis phases of planning helps incorporate visitor perspectives into the process. However, if you encourage members of your community to engage in conversation and respond to your existing offerings and planning ideas, you create a dialogue that will aid you in creating a master interpretive plan that, when realized, resonates strongly with your intended audience.

An example of supply and demand inventory and analysis from the Botanical Gardens master plan is provided in Section 5.5 below.

5.5. ANALYSIS

Together, the two stages of inventory and analysis are perhaps the most important part of any interpretive planning process. In an evaluation of several National Park Service interpretive master plans, Marcella found that the analysis stage in many of the plans could have been stronger in linking goals with recommendations by providing greater analysis and supporting rationale (Wells 2008). Analysis provides the proactive rationale—as opposed to a reactive justification—for decision making, and it demonstrates a deliberate, anticipated intention to best match supply and demand with planning goals. During analysis, planners need to consider what implications the supply and demand information and data have for directing interpretation and education efforts.

Analyzing Supply

Planning teams may find the following questions useful in analyzing supply:

- How are the museum's programs unique or special? To what extent do current levels of programming address the museum's mission and goals?
- How do recent planning efforts and relevant visitor research influence our thinking about and choices for interpretive media and programs?
- How might current museum staffing, funding, equipment, and resources affect the development and phasing of eventual or expected new facilities, exhibits, programs, and activities?

- Are there situations in which there need to be more, less, different, or new kinds of interpretation, orientation, wayshowing, or visitor services? What evaluation efforts, if any, support this thinking?

- Based on how we currently track visitors, is there anything we might do to enhance the monitoring of visitor experiences with our museum?

Other questions may also apply depending on what information is included in the supply inventory. Most important is reflection on what implications the supply information has for planning future visitor experiences with the institution. The following example of the inventory and analysis process recorded in the Botanical Gardens plan is instructive.

Supply Inventory and Analysis

Excerpted from the Education and Interpretive Master Plan for Coastal Maine Botanical Gardens (CMBG 2008)

What follows is one part of the inventory and analysis section of the Botanical Gardens' plan. This particular section inventoried CMBG's other existing Garden Plans and Planning Efforts. The analysis section for existing Garden Plans is included at the end of the example below.

Garden Plans and Planning Efforts

After years of planning and fundraising, the Gardens opened officially on June 13, 2007. Visitors to the Gardens in the 2007 summer season were able to enjoy a nearly completed facility guided by numerous site-planning efforts. The site-planning efforts that influence the work of this plan include the following.

CMBG Master Plan (2002) – this was the primary master landscape plan for the Gardens. It concentrated on the central four-acre campus that contains the Education and Visitor Center building. The schematic components of this plan (i.e., design maps) that are most relevant to this interpretive planning effort include. . . . *[An annotated list of circulation, art opportunities, interpretive concepts, surface treatments, site furnishings, and signage was provided here.]*

Plan for the Kitchen, Learning, and Children's Gardens (2004) – this is a secondary set of master planning documents that address three components of the main campus area:

- A Kitchen Garden aimed at creating an appreciation for the culinary qualities and social and healthful benefits of locally grown organic produce
- Children's Garden aimed at creating a sense of wonder and discovery about the rhythms of nature
- Learning Garden focused on developing horticultural knowledge and skill to produce locally grown organic produce

In addition, a list of topics relevant to garden programming appeared here. Three additional plans were inventoried: Plan for the Rhododendron Garden and Site Signage and Identity; Accessibility Review; and Native Plant Ornamental Garden Master Plan.

So What? *[Analysis comments regarding existing plans]*

The Gardens is now realizing the outputs of numerous planning efforts. In order to sustain a viable Interpretation/Education (I/E) program the following will be important as the Gardens implements programs based on these initial planning efforts.

a. In the short-term, focus should concentrate on completing non-personal I/E media before too many CMBG resources (time, money, effort) are expended on personal media (guided walks/talks, tours, classes, etc). In this way, the institution has time to be deliberate about personal programs so that eventual programs meet visitor expectations and have a better chance of being sustainable.
b. CMBG will want to use early visitor data and information provided in these plans to help establish benchmarks for future planning and decision making. The institution will likely experience some significant growth in visitation over the next few years and so it will be important to track that growth and continue planning for optimum visitor experiences.
c. Similarly, a number of topic ideas are presented in these plans and education staff will want to consider these ideas when developing program and media themes.
d. CMBG will want to ensure that I/E efforts are consistent with each of these planning efforts and (as appropriate) with Accessibility Review.

The purpose of supply analysis is to provide a logical, rational, and deliberate link between what exists currently in the museum and what implications that has for eventual interpretive options. This step ensures that the museum is making logical, reasoned decisions that are trackable (see sidebar, Flexibility in Planning) from goals through inventory and analysis to recommendations. Furthermore, analysis of museum

characteristics and resources will eventually lead the museum to over-arching themes and messages for educational products and services.

Flexibility in Planning

A good plan provides the institution with trackability, transparency, and accountability; however, some museums are averse to planning because they fear it will tie their hands when making decisions about future actions. With the future unknown and a host of variables that can change, most administrators want to retain maximum flexibility in order to remain nimble in case of change. Committing in writing to rationale for decisions is all too often perceived as a death knell for adaptive decision making.

Good planning does not, however, have to kill flexibility, nor does it have to handcuff decision making. Even with the best-laid plans, opportunities arise and conditions change. An interpretive plan can build in flexibility for these eventualities. For example, including decision criteria in the plan provides a mechanism by which new opportunities can be weighed fairly against other options, particularly if opportunities arise unexpectedly. Also, recording background or context, need, and inventory in writing provides a ready foundation for switching gears if new opportunities arise. A written record saves valuable time in decision making, especially when there may be new staff members who were not involved in the original planning effort.

Analyzing Demand

 In analyzing demand, visitor perspectives are central to team thinking and deliberation. The following questions may be useful for shaping these discussions.

- Has visitation increased, decreased, or stayed the same over time? What implications does that have for future exhibitions and programs?
- Is visitation to this area changing in other ways—for example, by season, by day of the week or time of day, by type of experience, by age or race, by activity, or by behavior? How might that influence our planning?
- Does the demand inventory suggest there are daily, weekly, or seasonal expectations that provide unusual, unexpected, or perhaps exciting opportunities for visitors? How might our planning accommodate this?
- Are there particular visitor groups or visitor characteristics that should be segmented or perhaps targeted with specific programs or services? How might this influence decision making?

(For example, young adults are less likely to attend a museum that does not allow cell phone use. Is a "no cell phone" rule still a necessity at our museum?)

- Are visitor expectations being met (or not)? For example, if inventory information was captured in a front-end evaluation effort related to visitor conceptions or interests, how might that influence interpretation at our museum? What do frequently asked visitor questions or complaints indicate about visitor needs or desires?
- What are the perceptions of our members? Do our new members respond or react differently to our exhibits and services than long-term members?
- What new visitors, or new audience segments, would we like to see in our museum? What barriers preclude their visiting? What might they expect? How might we reach them?
- What other reasons might people have for not coming to our area? How might we best invite them to take advantage of the opportunities here? Are there any partner or regional collaboration opportunities we could take advantage of?
- What new ideas have emerged about potential outcomes and impacts for visitor experiences at this site?

As we have stated before, the intent of this analysis is to provide logical linkages to eventual recommendations for exhibition and program plans. The Botanical Gardens plan again is instructive, as seen in the example that follows.

Demand Inventory and Analysis

Excerpted from the Education and Interpretive Master Plan for Coastal Maine Botanical Gardens (CMBG 2008)

Audiences

Since its inception in 1991, local residents and their guests have enjoyed the natural features of the Gardens. Although few written attendance records exist for these early years, from May 2007 through April 2008 the Gardens hosted over 38,000 visitors. Recent planning and site development efforts have increased the visibility of the garden, and subsequently more and more visitors will seek experiences at the Gardens—at least in the short term until awareness of the Gardens permeates the local communities and region.

Understanding audiences who seek opportunities here is essential for successful and sustainable Garden operations over time. A few initial efforts to understand audiences have been completed to date, and a number of other sources of information can be mined for insights into potential audiences. This section summarizes several of these information sources in order to shed light on the question, 'who are the CMBG audiences'?

Admissions Data

Admissions data is collected by the front desk of the Visitor Center during high visitation months. *[A table and description were provided in the plan.]*

Visitor Survey – Summer 2007

Prior to summer 2007, the Gardens had no systematic way of tracking or monitoring visitors since there was no formal point of entry. Now, with the new Visitor Center, visitation can be monitored more closely between April and December each year when the Visitor Center is open and admission charged. To begin a visitor monitoring program, an informal visitor survey was initiated during the 2007 summer season, and although this effort was not systematically sampled, the information gathered begins to paint a picture of the Gardens' visitors. Due to the bias introduced using this method, the reader is cautioned about generalizing too much about the following key findings.

- Approximately 20% of the 144 respondents were members of the Gardens; 26% additional respondents said they had considered becoming a member.
- Most visitors (90%) came "just to see the garden" and most respondents came with at least one other person (i.e., immediate family [41%], friends [38%], or relatives [21%]).
- A majority of respondents (57%) indicated they had visited other similar gardens in the past.

Additional findings from this survey continued here.

Stakeholder Meeting – March 2007

Anticipating the Gardens' need to understand its audiences, a series of on-site focus groups was conducted in March 2007 to determine what initial perceptions participants had about the Gardens and to solicit input about current and potential audiences. A full report was submitted to the Gardens in September 2007 and contains details of the procedure and results. *[Findings from this report were briefly summarized here.]*

Frequently Asked Questions – 2007

One of the easiest and most cost effective ways of capturing information about current visitors is to track frequently asked questions (FAQs). A modest (albeit non-systematic) effort to collect visitor questions was initiated when the Visitor Center opened in early 2007. The table below *[included in the plan, not reproduced here]* summarizes early results of this effort where questions are grouped by **process** (How do I 'do' the Gardens?), **content** (What can I see at the Gardens?), and **history** (Tell me more about this place.).

Local Area Demographics

Census data helps describe area residents and is useful for understanding local audience segments.

A table was included here that arrayed population, median age, ethnicity, median household income, median household size, and mean travel time to work for each of six local zip codes and for comparison to the same variables for the U.S.

So What? *[Analysis comments regarding demand inventory]*

Since this is its first interpretive plan, the Gardens are just beginning to organize their thinking about visitor experiences. The modest efforts in visitor tracking this year will need to be formalized into a rigorous and consistent effort for tracking and monitoring visitors over time. This is a critical component of operations and will need some priority attention in the short term.

Readers were directed to a later section of the plan for specific visitor monitoring recommendations.

Following a thorough inventory and analysis, planners should begin to see ideas about themes, visitor experiences, and interpretative and educational media and services emerging.

5.6. Themes and Visitor Experiences

Themes

Developing themes can be a fun part of planning. This pursuit is most effective once the necessary planning groundwork has been laid so that themes and key messages derive from what has already been written in

the plan about what is unique and significant about the museum and its collection, combined with the desired impact the museum hopes to make in the life of its visitors and in its community.

Themes are statements that express a central idea about a topic or concept (see sidebar, Themes versus Topics). They may be based on what makes the museum distinctive or special (on a local, state, or national level), why the museum's collections or mission is inspiring, and why people should care. Themes are compelling stories that help focus a museum's interpretive efforts. Although they are often self-evident after completing the early stages of a plan, deciding on their wording is often ticklish. A core team of two to three creative minds is best for drafting themes.

Master interpretive plans typically include one or more broad themes—statements that describe overarching stories for the entire museum. These themes do not restate the museum's mission statement,

Themes versus Topics

Terminology related to themes can be confusing (see our term cloud). The important point to keep in mind is that themes are not topics. For example, below are three topics:

- Simple topic: Art Deco
- Elaborated topic: Art Deco in architectural design
- Further elaborated topic: Art Deco in architectural design of Hoover Dam

None of these is a theme. Themes are best expressed as complete sentences that convey a cohesive content idea as a complete thought; for example:

- Much of the Art Deco artistry at Hoover Dam is a social mirror of the 1930s.
- Art Deco is the predominant artistic style integrated into numerous architectural features of Hoover Dam.
- The artistry of Hoover Dam reflects the accomplishments of several artists and architects over the past 70 years.

Each of these is a complete thought, although each conveys a slightly different meaning. Each of these themes might render a quite different program or exhibit approach; that is to say, theme development can and will influence the focus of subsequent interpretation.

which is an administrative guideline. Rather, they state big-story ideas that differentiate the institution from others of its type—one science center from another, one art museum from another, or one historical society from another. Often, tiered themes are useful for fully elaborating a broad theme (see CMBG example following). An overarching theme is broad enough to embrace several subthemes, but specific enough to focus the museum's educational and interpretive efforts and to differentiate its educational focus from other similar museums.

Themes and Subthemes

Excerpted from the Education and Interpretive Master Plan for Coastal Maine Botanical Gardens (CMBG 2008)

Overall Site Themes

The recommended overarching theme for CMBG was: **Coastal Maine Botanical Gardens exemplifies the natural heritage of Coastal Maine and provides an inspiring backdrop for horticulture, learning, and research.**

The following subthemes elaborated this broad theme by describing what is special about the Gardens. They also serve to delimit the Gardens' Interpretive/Educational Program.

Coastal Maine plants are important and fascinating. Based on the notion that plants are important to all human life, CMBG interprets plant life, basic botany, and biodiversity, and in addition, provides diverse opportunities for exploring these concepts against a rich coastal Maine backdrop.

Human life relies on gardening. Plants and gardening are basic to human survival but plants and gardening also fulfill a basic human need for beauty and renewal. Gardening at CMBG is a fun and exciting way to learn about the natural world where experiences enable visitors to explore Maine-hardy plants, learn about gardening by the coast, and practice useful gardening techniques.

Gardening is about natural systems and ecology. Coastal Maine Botanic Gardens interprets natural systems and ecology. The Gardens exemplify diverse coastal natural areas where natural processes occur constantly and where change is constant. Horticulture experiences help visitors appreciate the native ecology.

Environmentally responsible gardening leads to stewardship of the environment. Gardening teaches us about nature—about inter-connections,

about seasons, and about patience. Engaging in ecologically responsible gardening helps visitors steward the local environment and the planet.

Garden aesthetics are both natural and human-inspired. The beauty of the Gardens is primarily nature-based although human-inspired arts and design are integrated here. Natural forms, colors, and textures are the context for learning, reflection, and renewal, as well as the link to our human need for beauty.

Additional subthemes followed in the plan.

Visitor Experiences

 As we have stated, being visitor-centric means that museum staff share a belief that visitor experiences are essential to carrying out the mission of the organization. These experiences may range from an initial previsit website inquiry, to on-site visits, to post-visit reflections. Developing a vision for the desired visitor experience is an important piece of interpretive planning and one that is best done after audiences have been carefully considered in demand inventory and analysis. A vision for visitor experience is a statement that describes desired experience opportunities with the museum and thus tells the reader of the plan more about the expected relationship between the museum and the visitor. Such a statement, here referred to as the *vision for visitor experience,* may also be called a *philosophy about visitors*, or, as is common in the United Kingdom, an *education policy.*

An example of a vision for the visitor experience is shown in the next excerpt from the Botanical Gardens plan. In this case, desired visitor outcomes are also included.

Visitor Experiences

Excerpted from the Education and Interpretive Master Plan for Coastal Maine Botanical Gardens (CMBG 2008)

A Vision for the Visitor Experience

Garden visitors are the most immediate beneficiaries of CMBG efforts. As such, they require attention and nurturing. Satisfied visitors become return visitors, members, volunteers, and hopefully donors. The Gardens

will maximize sustainability by becoming visitors-focused in planning and management. Toward that end, the following vision for the visitor experience is proposed: **Visitors to Coastal Maine Botanical Gardens are provided diverse opportunities to explore and wonder where visitors can immerse themselves in the classic beauty and natural wonders of coastal Maine and be stimulated, engaged, and inspired.**

Desired Visitor Outcomes

Awareness and Decision-Making

- Visitors will explain where information about the Gardens (on the web and/or in printed materials) is located.
- Visitors will describe their options for traveling to the site and the available on-site experiences.
- Visitors will demonstrate that they can orient themselves to the site and comfortably find their way around the site.

Satisfaction and Learning

- Visitors will explain a part or parts of the story that they value.
- Visitors will recount exciting and personally meaningful experiences and share them with others. They will express a desire to return.
- Visitors will discuss with others their personal relationship with plants and with the natural history of the Gardens.

Additional outcome statements were included for The Story and its Cohesiveness, Discovery and Empowerment, and Staying in Touch.

Key Garden Experiences

Recognizing that visitors have varied reasons for coming to the Gardens and that those reasons change over time, with the seasons, and depending on the social group, differentiating experiences for visitors will be important. Identifying key experiences for each of the specific areas of the Gardens is helpful in planning. This is not to say that the key experiences described below are mutually exclusive or self-limiting. Rather, they are meant to help distinguish the diversity of garden opportunities and to eventually help visitors maximize their visitation choices.

Key Experiences in the Main Campus Area

- Clever Event Lawn and Garden: SOCIAL – events, people, open space, lawn, sun, warmth, special plant collections (e.g., Kousa dogwood)
- Slater Forest Gardens and Pond: TRANQUIL – shade, water, flowering plants (including immersed, e.g., water lilies), mature pines, stepping stones, nature sounds
- Woodland Garden: RESTFUL – quiet, wandering, natural, shade plants, stones, mosses and ferns

- Rose/Perennial Garden: CLASSIC – roses and perennials, colors, gazebo, pergolas, mottled light, unique flora, fall color gardens

This list continued with garden areas that offer Calming, Playful, Inspirational, and Sensory experiences in the main campus area, and Historic, Fragile, Adventurous, Youthful, Colorful, Aesthetic, and Reflective experiences in other areas of the property.

Some plans nest themes, visitor experiences, and visitor outcomes together by topic or theme. The following example comes from a historic site interpretive plan where "Cultural and Historic Resources" was one of several core topics elaborated with a theme, visitor experience, and visitor outcome.

Nested Themes, Visitor Experiences, and Visitor Outcomes

Excerpted from Staunton State Park's Community Connections Plan: A Roadmap for Interpretation, Education, Outreach and Partnerships, master interpretive plan of Staunton State Park near Denver, Colorado (Colorado Parks and Wildlife 2012)

Topic: Cultural and Historic Resources

Compelling Story (Theme): Staunton State Park is the legacy of Frances H. Staunton. As her beneficiaries, present and future generations are entrusted with this land—to enjoy, protect, and treasure as she did.

Visitor Experience: Visitors will "meet" Frances H. Staunton and learn about her considerable contribution to the creation of this park.

Visitor Outcome: Visitors will recount how Staunton State Park got its name and will develop a sense of protectiveness toward the Park as a gift to Coloradoans from Frances Staunton. Visitors will care for the Park by following Park regulations, picking up litter, and reporting concerns to staff.

In developing desired outcomes for a master interpretive plan, planners should consider the goals of the plan and should reference the desired impacts on audiences and the community as already set forth in the plan (see Sections 5.2 and 5.3).

5.7. RECOMMENDATIONS

Recommendations
Deliverables,
Key Initiatives,
Activities, Programs,
Opportunities

Based on the inventory and analysis, and given the guidance of themes and visioning of visitor experience for the entire museum, planners can now discuss broad recommendations. In a master interpretive planning effort, recommendations for key initiatives might include exhibitions, educational programs, interpretive activities, interpretive media such as signs, brochures, gallery guides, and website material, webcams or other technology options. Some plans may also include recommendations for visitor orientation and wayshowing.

Recommendations for key initiatives should derive directly from the inventory and analysis, since the need for these initiatives is supported by information and data already deliberated, discussed, and recorded in the plan. In this way, interpretive planning is proactive in recommending engaging visitor opportunities. Planners should consider the following questions as they formulate recommendations:

- Recognizing the background of our organization and what we have discovered from our inventory and analysis, what approaches and delivery methods are best for the visitor experiences we are trying to create?
- What target opportunities might help us best match our museum's supply of goods and services with existing and future demands by audiences? Given our unique collection (or site, or facility), what types of exhibits, programs, activities, and media are most relevant for our audiences?
- What alternatives exist? Do we want to consider and evaluate alternatives for content, approach, and delivery system before we make final recommendations? If so, what decision criteria should we use to make those final recommendations?
- What staffing changes, resource changes, or changes to existing facilities might these initiatives require?
- What collaboration between departments within our own institution would be useful?
- What partnerships with external stakeholders or organizations might be appropriate or beneficial for stimulating community engagement?

Some planners find it prudent to engage the public at this stage of planning, rather than to develop recommendations based solely on

internal assumptions about need, audiences, and opportunities. Public open houses, community discussion groups, focus groups, and online surveys are common methods for engaging the public in discussions at this stage. The planning team may invite the public to generate ideas before options are elaborated (front-end approach) or to respond to proposed ideas once options are developed in concept (formative approach). Some museums wisely use public discussions or visitor panels (see Fischer 1996; 1997) to check their assumptions about prior decisions or to gather feedback on plan recommendations. During the planning process, such a group gradually gains a deep understanding of the museum and its goals and mission, and can offer a cost-effective sounding board that is extremely useful in planning.

As museums gain recognition as institutions of significant public value, they are becoming accustomed to engaging the public and are beginning to allow visitors to bring their important perspectives to the discussion—visitors are the experts on what they know, what they want to learn, and how they want to learn it. Museums are finding that the integration of visitor, community, and museum perspectives results in engaging and relevant learning opportunities.

The degree of specificity for interpretive recommendations in a master interpretive plan may be quite general (see the following Botanical Gardens example). Some master plans recommend fairly general strategies and goals, recognizing that full detail will be developed later in specific project interpretive plans. Other planners outline recommendations in detail. In other cases, prior to making final planning recommendations, the planning team discusses a set of alternatives and then sifts through them using a set of decision criteria to make reasoned final recommendations. Once planners make final recommendations, they should include original alternatives and decision criteria as part of the administrative record, for example in an appendix. For more on decision criteria, see Section 6.7.

Recommendations

Excerpted from the Education and Interpretive Master Plan for Coastal Maine Botanical Gardens (CMBG 2008)

As the Botanical Gardens plan was the organization's first master interpretive plan, recommendations constituted a significant part of that document. They were organized into two sections: Staffing and Visitor Monitoring Recommendations, and Interpretation/Education Program

and Media Recommendations, each including several recommendations. (These are listed in the Table of Contents for this plan in our Appendix B). Excerpts from the two sections are included here to illustrate the types of information and detail that can be included in a recommendation in a master interpretive plan.

Staffing and Visitor Monitoring Recommendations

[Sections under this heading included: Recommended Staffing Levels, Staffing Position Descriptions and Qualifications, and Other Staffing Considerations, followed by the section detailed below.]

Visitor Segmentation and Monitoring

Audience inventory and analysis suggests that CMBG has initiated but not perfected a visitor tracking and monitoring program. Based on that analysis, the following recommendations are offered.

- Target and Maximum Visitor Capacity – Original planning anticipated visitation fairly accurately. In addition, original target capacity of between 30–40K visitors per year (Strategic Plan) was realized for the 2007–08 year. This early realization of nearly 40K visitors may eventually threaten the maximum capacity projection of 50K described in the Strategic Plan. The Board and staff will need to carefully track and monitor visitation over time and either adjust capacity or manage for maximum capacity accordingly.
- Admissions Data – Admissions data is an essential tool for tracking visitor use of the Gardens, however, the current data reporting is awkward and cumbersome. For example, monthly admission records break down into about 13 categories of visitors but family visitors have to be manually re-calculated, school/camp visitor counts are not accurate because some of those visitors are counted by the Education Department, the Pre-book category is likewise misleading since some of those programs are also tracked separately by the Education Department. It is critical that the Gardens re-evaluate and adjust its tracking procedures and/or software to provide an accurate, clear, and comprehensive summary of visitors. For example, the Marketing Department and the Education Department should consolidate all registrations, visitor counts, program participants, and other admissions into one mechanism that captures all users of the Gardens in one place. *[Continues, with additional details and guidance.]*
- Visitor Surveys - Although the 2007 summer visitor survey was not systematically sampled, the highlights are helpful in establishing tentative benchmarks until which time more systematic visitor information can be gathered. For example, the 2007 data suggested that about 20% of the visitors are currently members. Using this as a benchmark, a

reasonable goal for total membership in 2008 might be 25% of all visitors. The summer 2007 data should be discussed by staff and board for other useful benchmarks and to inform a subsequent (and more systematic) visitor survey effort. Most importantly, continued and systematic visitor monitoring (e.g., exit interviews, surveys, comment cards) should be discussed and developed as an integral part of operations. This may require professional consulting to help design a systematic and reliable process for tracking and monitoring that might include more than just numbers (e.g., satisfaction, interests, expectations).

Recommendations continued for Frequently Asked Questions and Demographic Data.

Interpretation/Education Program and Media Recommendations

Literally hundreds of program ideas have been generated for the Gardens in recent years—by planners contracted to the Gardens, by CMBG staff, and by local residents (See Wish List) *[not included here]*. Recommendations below are categorized into the following five categories: (a) Non-Personal Media, (b) Personal Programs, (c) School Programs, (d) Special Events, and (e) Outreach Programs. The recommended percent effort for each is shown in Table 9 *[not included here]* and priorities for each of several projects are described on the following pages.

Below is a single sample recommendation from this section of the plan.

Interpretive Wayside Panels

Product Description and Goal: Develop a series of modest interpretive wayside panels to be placed throughout the Gardens (Main Campus and in dispersed areas of the garden). The purpose of these signs would be to provide visitors with interpretive explanations of specific garden areas and themes without creating a sense of sign litter across the site.

Signs would be developed in two phases where Phase I signs are designed and prototyped in Su08 and fabricated and installed in 2009. Phase II signs would be designed and prototyped in Sp09 and fabricated and installed in 2010. Sign sizes may vary depending on content and location, but all signs would adhere to common design guidelines to be developed by the Gardens prior to or concurrent with the development of these signs.

Target Audience: First time visitors and all visitors who wish to explore the various areas (and respective natural/cultural history) of the garden.

Topics and Key Messages: The chart below contains a summary of specific locations and key messages for 13 sign areas (totaling 24 individual panels). During the design development phase, the suggested topics

should be more fully developed into themes, and content researched and developed. At that time redundancies or reshuffling of content should be addressed. *[A substantial table describing sign locations and suggesting key messages for each was located here in the plan.]*

Cost Estimate: *[approximate dollar range, omitted]* to cover,

- Content development (research, writing, image acquisition, overall panel design)
- Design development (brand/look, design and layout, and production files)
- Original illustrations as required
- Formative evaluation of prototype panels
- Fabrication, framing, and installation

Additional descriptions were included for a history of the Gardens and fact sheet, a technical bulletin series, an electronic plant-finding aid, and numerous educational programs.

5.8. IMPLEMENTATION GUIDELINES

The implementation guidelines section of a master interpretive plan demarks where the planning stops and the work of implementation begins. It summarizes what resources, materials, and efforts are needed to implement final plan recommendations. It should address the following questions:

- Funding: What are the general budget implications for each of the recommended key initiatives? How might funding for the various key initiatives be organized or pursued?
- Staffing: Who will be involved in implementing the recommendations of the plan—staff, contractors, partners, volunteers? What skill sets or qualifications are needed? What processes for staff allocations or contracting are necessary or desirable?
- Resources: In general, what other resources (supplies, materials, equipment) are required to develop, or at least move forward, the final recommendations of the master plan?
- Time and sequencing: In general, what are the steps, stages, or sequencing required for completing the work of the plan? Is there a proposed time schedule for implementing the various recommendations of the plan?
- Approvals: What processes or approvals are required to proceed with the recommendations of the plan? How might these approvals influence desired action on this plan?

 In addition, to ensure that the plan is truly integrating visitor perspectives, it should include some general guidance about how the impacts and outcomes proposed in the plan will be monitored or evaluated, and how progress will be shared with internal and external stakeholders. This guidance may be general, but nonetheless should consider:

- How does the museum think about evaluation research and visitor studies? For example, is evaluation common practice currently, or is it something that needs to be developed? If it is common practice, is evaluation done in-house, contracted, or both?
- Who will develop final measurable outcomes for the specific program components recommended in the plan? When and how will that happen? What are the best processes for sharing progress?
- What are the expectations for an evaluation plan? Will evaluation be accomplished in-house or contracted?

Planners should include in the master plan a narrative that covers these issues. The Botanical Gardens plan again provides an example.

Implementation Guidelines

Excerpted from the Education and Interpretive Master Plan for Coastal Maine Botanical Gardens (CMBG 2008)

Implementation Guidance

Planning is only the first step to implementing a successful I/E program. The guidance below is meant to help in the transition from planning to implementation.

Research and Writing – The content of any sign, exhibit, publication, or program needs to be researched carefully for content, accuracy, relevance to audience, and even political correctness (as appropriate). A diversity of resources should be considered during this phase including but not limited to content specialists, publications and technical documents related to the main messages, library records and archives, local community records and information, local content experts, web resources, and so forth. Sufficient time should be allocated to research concepts but also to construct accurate and appropriate interpretive text for the proposed products. Creating stories, comparisons, and creative narrative that is provocative and relevant for visitors is a creative process that takes time. This allocation of time needs to be factored with staff scheduling.

For interpretive media, a critical (and often overlooked) part of the research and writing phase is photo and graphics acquisition. This is the responsibility of the research and writing team or staff, and includes

locating all photos, charts, graphics, illustrations, or other visual material needed to enhance the written messages. Often it is necessary (or desirable) to pursue original illustrations to complement the interpretive messages. The additional costs associated with contracting an artist for original illustrations needs to be considered in the interpretive planning budgets.

For both media and programs, it may be necessary to include front-end evaluation as part of the research and writing phase to probe visitor perceptions (or misperceptions) about specific topics, themes, or ideas. Focus groups, visitor surveys, or interviews may be needed to determine the level of visitor understanding of or interest in interpretive content.

Design and Layout – For interpretive media, graphic artist skills are invaluable in the interpretive development process. The role of the graphic artist is to take interpretive narrative, photographs, illustrations, and/or graphics that have been gathered during the research and writing phase, and put them into an artistic and professional layout appropriate for visitors and consistent with planning and management expectations. The design and layout process involves developing a design "look" that is appropriate for the project, scanning all images, color manipulation as needed, and acting as liaison with fabricator to ensure desired output.

Two of the overall goals for design and layout should be, (a) consistency of design (e.g. color, specific design elements, and overall 'look'), and (b) appropriateness to existing site design. Design and layout typically involves several iterative discussions between graphic designer and interpretive writers, content experts, artists, and project manager. The planning budget and timeline should take this into account. Some projects take only 2–3 iterations for success while others take 10–15 iterations for success. Anticipate this in planning.

Guidance continued with discussion of Design Development/Exhibit Design, Construction Drawings, Fabrication, and Installation. Also included was a brief section on Resources for Interpretive and Education Training.

A master interpretive plan provides a broad backdrop and an impetus for interpretive and educational recommendations, which may then be more specifically elaborated in project interpretive plans (see Chapter 6). At this master scale, a plan should describe the museum's desired relationship with its community, and it may be used to provide information to any number of stakeholders when seeking funding, to contract with a design firm or evaluation contractor, or to showcase the institution's interpretive vision to community leaders. Always, the master interpretive plan should be customized for the particular institution and should serve as a source of pride for guiding decisions about appropriate and meaningful visitor experiences.

Chapter 6

INTEGRATING VISITOR PERSPECTIVES IN PROJECT INTERPRETIVE PLANNING

6.1. INTRODUCTION

Interpretive planning for a singular key initiative such as an exhibition, program, or activity is similar in concept to but different in scale from master interpretive planning. The process is generally the same, although the questions focus more specifically on the project at hand, and the level of detail is greater.

For some, project interpretive planning and exhibit development are synonymous. Although they both have the same goal—to explicate an interpretive deliverable or key initiative (e.g., exhibition, exhibit, program, activity) for audience engagement and learning—as shown in Figure 6.1, the planning phase involves the work of information gathering, deliberation, and decision making prior to detailed exhibit development.

In *Planning for People in Museum Exhibitions*, Kathleen McLean (1993) diagrams a design process based on industrial engineer Morris Asimow's (1962) model of a process for problem solving in design (Figure 6.2).

Project

Exhibit, Exhibition, Activity, Program, Event, Curriculum

Project Interpretive Plan

Interpretive Exhibit Plan, Short-Term Interpretive Plan, Exhibit Plan, Interpretive and Education (I&E) Plan, Concept Plan

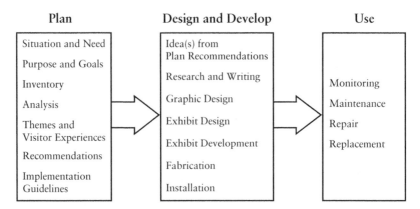

Figure 6.1 Context for Exhibit or Project Planning

McLean also integrates visitor studies phases (e.g., front-end, formative, and summative evaluation) and suggests iterative review and approval throughout the process. She does not clarify, however, some of the important decisions that precede design and development, the handling of questions that we have posed in this book. If a funder, trustee, or community leader, for example, wants to understand the larger context within which an institution is developing an exhibition, what documentation exists about decisions and rationale regarding the need, goals, themes, and visitor experiences for this particular initiative?

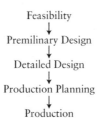

Figure 6.2 Activity Phases of the Exhibition Development Process
(adapted from McLean 1993)

One important step in formulating a project is deciding where to draw the line between planning and development. Traditionally, exhibit development has been the purview of teams of designers and fabricators, with curators or scientists leading content development. More recently educators, interpretive specialists, and sometimes exhibit writers have been added to the team to improve communication and focus. But much of the work that is being done is grounded in the *what*—what we have, what we could do, what we want to say. Many times the final product

lacks the *why*—why we are doing this project at this time, for what specific reasons, where the impetus for this project came from, and what it is really intended to accomplish; is the project even relevant for this institution? Project interpretive planning ensures a strong foundation for answering these questions. It anchors the project in the organization's mission and helps align it with audiences' needs.

A project interpretive plan is useful: (a) as an historic record of decisions in case of personnel changes during the implementation of the project; (b) for contracting work such as evaluation, content development (e.g., research and writing), graphic design, fabrication, and implementation; and (c) as accountability documentation for tracking progress and productivity against the institution's master interpretive plan. In the absence of a master plan, the task of project interpretive planning is more difficult, as there is little or no supporting material on which to ground discussion and decisions. Planners may have to work without a supporting context and rationale for education or interpretive priorities at the institution scale; thus the relevance of the specific project for the institution or community may be vague. They may also have no supporting information about or discussions of visitor perspectives. In the ideal situation, all of an institution's plans support and connect to each other, clarifying roles, responsibilities, and directions.

Interpretive projects vary in scope and scale, for example, from a large reinstallation of a permanent gallery organized by a large planning team, to the development of an after school program by a team of one. Obviously, the scale of the plan document will align with the scale of the project and hence will range from numerous pages to only a few. Most important is the systematic process of moving through decision points and questions to ensure alignment with the institution's mission and goals, the community's needs, and the project's specific situation. The project interpretive plans referenced in this chapter as examples are all exhibit plans; keep in mind, though, that project plans can be developed for any number of project types, including events, programs, exhibitions, traveling exhibits, and educational activities, to name a few.

In the following sections, as in the previous chapter, we provide questions to guide thinking and deliberation in the interpretive planning stages. Again we have inserted small triangle icons, representing the Outcomes Hierarchy, to suggest where you will especially want to consider visitor perspectives. To elucidate the practice of project planning, we include in this chapter several excerpts from an actual plan entitled "Maharaja: The Splendour of India's Royal Courts." The Maharaja exhibition was originally developed by and for the Victoria and Albert Museum in London, England. It was later modified and offered by the Art Gallery of Ontario (AGO) in Toronto, Canada, as a temporary exhibition in 2010–2011. Not all planning steps recommended by this

book were included in the AGO's plan, and hence we bring in portions of other plans to illustrate some planning stages—specifically, examples from the Walking Mountains Interpretive Plan and Concept Design from an exhibition for a science center in Avon, Colorado (2010), and a Hoover Dam Visitor Center exhibit project (Bureau of Reclamation 2002). (In the excerpted examples, italics indicate our commentary; format and punctuation in the excerpts follow their originals.) Each program plan is by necessity unique based on the culture of the institution and the needs and goals of their specific project.

6.2. SITUATION AND NEED

A project interpretive plan focuses on a singular key initiative. The project may be the result of a recently received grant, or it may be a response to a special opportunity. In a perfect world, it would already have been envisioned as one of several recommendations of a master interpretive plan. Regardless of its origin, it is likely to be a project that serves an identified institutional need that aligns with the organization's mission. The impetus for a project can arise from any number of sources, including institutional need (e.g., grow young audiences), community need (e.g., more positive youth development programs), or new funding (e.g., grants for girls in science). Whatever the impetus for the program, developing a project interpretive plan should help to align and integrate the needs of all stakeholders involved.

As with a master interpretive plan, the initial portions of the project interpretive plan address situation and need, although in this case the situation and need focus on the project-specific context. This part of the plan should include relevant background of the project or any documentation that supports the need for the project. The introductory material might include a brief statement about why the organization is pursuing this project at this time, the project's connections to the museum's mission and strategic plan, plus planning considerations relevant to the project, such as any facility, staffing, political, or funding considerations that are unique to the particular project. If an institution-wide master interpretive plan already exists, the project plan should describe the linkage between the two planning efforts—presumably, the more specific project plan is generated from a broader master plan. For example, the project plan may put into motion one of the recommended programs or activities that had been suggested in the master interpretive plan and for which funding has now been secured.

 In the initial stage of planning, the team should consider desired impacts of the planning effort. If there is a master interpretive plan, projected impacts and outcomes described in that document should have been stated in fairly general terms. This is a good time to discuss and

compose more project-specific impact statements. If there is no master interpretive plan, there may be little or no prior direction, and so the team may need to determine the most relevant and reasonable project-specific impacts they hope to achieve.

Situation and Need

Excerpted from documentation associated with the Maharaja exhibition interpretive plan, Art Gallery of Ontario (AGO 2011)

Much of the rationale for the Maharaja project was captured in foundational documents developed to move the potential exhibition through the organization's approval process. Those documents, summarized in excerpts below, acted as a statement of institutional situation and need for this project. The actual interpretive plan for this exhibition contained much of the information detailed in this chapter, but overlapped with what many might consider the exhibition development plan. Thus, the work of interpretive planning that was completed by the institution was captured in a number of documents.

Connection to Mission: Committed to serving the large (6.5 million) and extremely diverse metropolitan area of Toronto, Canada, as well as the province at-large, the Art Gallery of Ontario plans a temporary exhibition showcasing the art and culture of India. Our mission, "we bring people and art together, and boldly declare that art matters!" ensures we place an emphasis on cultural exchange, participation, and connections to everyday life experiences in all we do. Our community comprises a large and robust South Asian community which is not currently reflected in our collection. A temporary exhibit will assist us in building long-term and deeper relationships with the community, growing our audience, and expanding our community's understanding of South Asian art.

Impact: As a result of engaging with this exhibition, and its related programs, the broader community will learn about the South Asian artistic and cultural traditions. The South Asian community will see itself reflected and valued in our museum.

6.3. PURPOSE AND GOALS

Following a description of the situation and the need for the project, the planning team will want to discuss project goals. Remember that goals are not the same as desired outcomes; they are statements of intention and are worded from the institution's perspective. Goals further define the general purpose of the project; for example, a goal for an exhibit in a new space might be to stimulate increased partnerships with local schools for curriculum-based field trips. Another goal for that same project might be

to increase family attendance at the museum. For a new art exhibition, an overall goal might be to showcase the work of a preeminent local artist or to feature a new acquisition or a particularly compelling part of the collection.

In some cases, the plan may include multiple goals; if the project is large or extensive, planners may want to include goals for each of the various units to help differentiate the institution's intent for each unit or area.

Purpose and Goals

Excerpted from documentation associated with the Maharaja exhibition interpretive plan, Art Gallery of Ontario (AGO 2011)

Traveling exhibition period: November 22, 2010, to April 2, 2011.

Institutional Goals and Target Audiences:

(a) to increase engagement with Southeast Asian community
(b) to stimulate an additional 125,000 visitors, 40% of which will become members

Project Core Team: Project Manager, Interpretive Planner, Consulting Curator, 3D design, 2D design, and conservator.

Project Team: A representative from all other areas of the institution such as development, marketing, visitor services, sales, food and beverage will be assigned.

Exhibition's 'Big Idea': This 10,000 sq. ft. exhibition showcases the diversity and splendour of India's artistic traditions as shaped by its royal courts, engaging visitors in 300 years of wealth and power, beauty and conflict, as the lives and legacies of India's kings are revealed.

The inclusion of a "Big Idea"(Serrell 1996) at this stage of interpretive planning relates to the fact that this project was the modification of an existing traveling exhibition that had already been formulated based on an important idea. In some situations a big idea or theme is identified very early in the planning process, in which case, demand analysis allows us to better align that idea with the target audiences' needs and preferences.

6.4. Inventory

The inventory section of a project interpretive plan reviews what the museum *has* and *knows* related to the focus of the planned project or activity. In order to describe the specifics about the project, the team should first inventory the current condition of both supply and demand.

- Supply: What do we have currently within the institution that pertains to this particular project? What currently exists to

help us think about and make decisions about this project (e.g. specific staff, relevant collections for this project, research documents that pertain to the project, other plans or guidance)?

- Demand: What do we know currently or what can we learn about the public's demand for this project? Who is our audience and what do we know about them and their interests, opinions, cognitions related to the content focus of our project?

The supply inventory for a project interpretive plan will be specific to its goals. Sample questions for inventorying supply at this stage include:

- What parts of our collection (or, in the case of the Maharaja project, what parts of the traveling exhibition) will be used for this exhibition? Are there objects or photographs that we will need to obtain from other institutions or sources? Are there stipulations about acquiring, using, or crediting those photos, images, objects, or original art that we need to consider? What, if any, are the conservation requirements for the objects we hope to use in the exhibition?
- What parts of our facility are implicated in this new project? Will there be need for demolition, repair, electrical wiring (power outlets), maintenance (cleaning or painting) prior to installation? Are there design considerations (ceiling heights, door widths, structural support) to be addressed?
- What is our current staffing for this project?
- What is our current budget for this project? How will it be funded?
- What educational resources (e.g., staff, volunteers, research resources, library materials) do we have in-house for developing this exhibition?
- To what other activities, projects, or resources in the community might this project relate or link?

Depending on the size and nature of the project, other supply questions may also be relevant.

Supply Inventory

Excerpted from documentation associated with the Maharaja exhibition interpretive plan, Art Gallery of Ontario (AGO 2011)

- Object List:. . . . *[Most often would be chosen by the curator and exhibition team; in the case of this traveling exhibition, an object list was agreed to in negotiation with the originating museum. The list included size, materials, and conservation requirements.]*

- Guest Curator Agreement:. . . . *[As the AGO did not have a South Asian specialist on staff, a guest curator was contracted for the development and implementation of the exhibition.]*
- Catalogue: an existing catalogue, developed by the originating institution, is available for purchase.
- Development:. . . . *[A detailed proposal for targets and prospects was included.]*
- Schedule:. . . . *[A schedule matrix showed that the work of this traveling exhibition could be accomplished without conflict with the museum's existing commitments.]*

Demand inventory addresses questions about the audience. This may include data or information about the visitors in general or about specific audience segments that might become visitors for this particular project. Demand or audience inventory questions include:

- Who are our target audiences for this project? What, if anything, do we already know about them?
- What segments of overall public demand for this topic or project do our current visitors represent? Will this project confuse, frustrate, or otherwise alienate any visitors or audience segments?
- Who is not represented in our current visitation that we hope to reach with this project? How might we reach these people? What do we know about these people and their interests or opinions about the content of our project?
- What visitor entrance narratives exist related to this project's content or message? What are their expectations for a project like this?
- Is there current research that supports visitor experiences like the one we are trying to develop?
- Is seeking input from potential visitors needed to better understand where to begin the story we want to tell? If so, how might we go about getting that input or information?

Although much of this inventory can be gathered and described by the planning team, sometimes the help and advice of an evaluator is useful. Early demand work for planning, at times called *front-end evaluation*, is carried out in the interest of the audience (current and potential audiences alike). Knowing about current and possible audiences is essential for describing potential impact and eventually for developing specific outcome statements. Discovering what visitors bring to the experience will clarify how to anchor the product within existing audience experiences and knowledge.

If there is an existing master interpretive plan, it likely includes a broad discussion of audience; providing additional detail now about

specific target audiences for the particular project is essential. This is the point at which museum staff should ensure that the needs of the visitors, membership, and community are clear and that this particular program will target that demand; planners can thus work to avoid the pitfall of staff being blinded by the excitement of a new idea or new acquisition. With a thorough demand inventory and analysis, planners can help staff aligning their enthusiasm with community needs and desires. The AGO, before agreeing to take the temporary Maharaja exhibition, conducted a demand and audience inventory that included a marketing review of potential new audiences; they also examined a summative evaluation of a prior "immersive" exhibition at their museum looking for information about audiences' appreciation of and demand for future culturally immersive opportunities, as well as the types of experiences they most preferred.

Demand/Audience Inventory

Excerpted from Walking Mountains Interpretive Plan and Concept Design, Avon, Colorado (2010)

Audience Inventory Included in Walking Mountains Business Plan

According to the most recent Business Plan, the science school segments its program by the following audience:

- Student Programs reach approximately 3,000 local youth/year in partnership with local schools;
- Community Programs reach about 18,000 adults, families, and youth annually;
- Professional Development Programs train and mentor about eight educators each year.

In addition, the Market Analysis contained in the Business Plan suggests that the community population continues to grow due to increased tourist visits, retired baby boomers, and increased demand for construction and service workers. This trend however, does not take into account the economic recession (2008–2009) that continues to affect both tourism and construction. It is difficult to say what long term impact this may have on Eagle Valley's population and demographic; however, some data presented in the Business Plan points to some likely enduring trends, such as:

- Whereas the vast majority of residents continue to be Caucasian (76%), County Schools now contain 50% Hispanic students; one-third of whom are still learning English.

- Depending on the eventual effects of the recession, student enrollment in the local schools will likely continue to grow—perhaps at a slower rate than originally projected, but grow nonetheless.
- Current county population is about 50,000 and yet resort lodges in the valley host over 1 million visitor nights per year.
- Barring significant effects of the current recession, population growth in the county is projected to reach 80,000 in 2020 which will continue to transform the valley from a rural mountain community to a suburban corridor.
- The majority of tourists (70%) are above age 31; 61% are male, and over one-third (36%) have household incomes of $200K/year.
- Nearly half (46%) of the valley's residences are owned by second home-owners and part-time residents. These people spend about 50 days/year in the valley—time mostly spent during peak winter (Dec–Mar) and summer (Jul–Aug) months.
- Motivations for owning property and/or living in this area include the attractive outdoor lifestyle, outdoor recreation (particularly skiing), and overall quality of life.

Several tables containing county demographic data and age cohort data were included here.

A few conclusions can be drawn from these data:

- The annual percent change for young children (15 and younger) has gradually decreased over the recent decade from a high of nearly 6% to a low of 2.7%.
- The annual percent change for adults ages 16–44 is very small, less than 1% annually for the last decade. This may be an indication of the transient and seasonal nature of jobs for people this age in this county. It would seem that this age group does not seem to stay in the area.
- Annual percent change for the 45–54 age group has generally declined, slowing over the last 10 years fluctuating between 7% and 1% (most recently).

The annual percent change for the 55–64 age group was fairly steady at around 10% for the first few years of the decade before decreasing slightly to between 7% and 9% in the past few years. And so it is understandable that the annual percent change for the 65 + age group has started to increase in recent years to between 8% and nearly 12%. Eagle County is an attractive location for retirees which squares with the projection that this annual percent will continue increasing each year for the next several years (projected to be 12% by 2015).

Data and information on recent Hispanic audience research was also included.

6.5. Analysis

The purpose of supply and demand analysis is to provide a rational and deliberate link between what exists currently at the institution and the implications that has for the specific project. As described in the previous chapter, this step ensures that the project team is making reasoned decisions that are logical and that are trackable from original project goals to final implementation. A written analysis is an essential part of a project interpretive plan and should answer the questions: What are the implications of the information gathered, and how does that shape our ideas for this project? For example, what implications are apparent from the supply inventory of staffing regarding content development, exhibit design and development, fabrication, or installation? Will current staff members have to take on additional responsibilities during the life of this project, or will some of the work be contracted? Will content specialists, illustrators, writers, or others be part of the internal team, or contracted? What implications does that have for the budget and the schedule?

The following, more specific questions may also be useful in discussing the analysis of data and information gathered during supply and demand inventory:

- Do we have what is needed to fabricate and implement this project? If not, what other resources are needed; what other expertise might we need to contract?
- What implications for this project are indicated by the data and information we gathered about expected or potential audiences? How might conducting visitor studies throughout the life of this project help us?
- If a front-end evaluation was done: Do the initial project ideas resonate with the proposed audience? What do the results of the evaluation mean for continued work on this project?

The analysis will show whether the proposed ideas and outcomes are aligned and whether all the needed resources are available to go forward with the project.

Demand/Audience Analysis

Excerpted from Walking Mountains Interpretive Plan and Concept Design, Avon, Colorado (2010)

Population and Programming: No one knows what impact the current recession will have on mountain resort communities of the region, but

based on recent census and demographic data, the following are considerations for programming at the Science Center:

- Primary audiences for the Science Center programming and experiences will likely continue to be school students and youth in the valley. Secondary audiences are clearly adults (and especially seniors), families, and area visitors and tourists.
- With that said, programming for youth and families does not come without challenges, not the least of which is the high Hispanic population in the county, but also a slightly declining youth population in the county.
- The senior population appears to be the one segment that will continue to grow annually for a number of years. This may require renewed or different attention in programming by the School.
- Age category projections suggest an obvious and viable niche for multigenerational educational opportunities, particularly with grandparents or seniors and youth.

Audience segmentation as it relates to school programming is more fully described in Section 6 of this plan.

Effort Allocation: The primary focus for the Science Center has been on student programming in natural areas of the region. Over time, community programming has grown as a strong secondary priority. With the design and development of the Mountain Discovery Center *[on Walking Mountains' campus]*, the effort allocation for balancing programming for both student and community should be monitored. Section 6 *[not included here]* of this plan offers several programming recommendations that suggest a 50:50 effort allocation to both these two audiences. What is uncertain is how much informal education effort will need to be expended for walk-in visitors. Part of the monitoring and tracking effort should address how this effort allocation might change over time.

Hispanic Audiences: Most all data for this region suggests a continued growth in Hispanic/Latino populations. Most directly, this impacts student programming with the area's school youth. Many area schools report between 50–90% Hispanic student populations. Currently, school instructors incorporate best practices for English Language Learner Program (ELL) in school programs. The practices should continue, but program enhancements for this audience may need to be enhanced in the future, especially for community programs and on-site experiences. A multi-lingual institutional philosophy is provided at the end of Section 4 *[not included here]* as a start.

6.6. Themes and Visitor Experiences

Some planners address themes in the initial stages of interpretive planning. In fact, some planners start with themes. As the Maharaja example illustrates, an overarching theme often is one of the early considerations of a project

plan. However, detailed theme development is best considered following inventory and analysis, as it is that thinking and deliberation that helps the team focus project content appropriately to both supply and demand.

As we have discussed in Section 5.6, themes are complete and compelling statements about topics or ideas. In the case of a project interpretive plan, themes are based on the uniqueness of the collection, topic, or idea to be developed in the project plan. Once the team has completed and recorded the situation, need, inventory, and analysis, they can more effectively develop themes and key messages for the specific components of the project. Keep in mind that the project is still in planning stages and thus topic ideas or themes are still being considered based on the goals of the project and on factors such as the available square footage.

Themes

Excerpted from the Maharaja exhibition interpretive plan, Art Gallery of Ontario (AGO 2011)

The following is a list of the overarching themes of the exhibition, which in this case are written as visitor questions that the exhibition is designed to answer. The themes were subsequently broken into thematic and geographic subsections called zones, *which were developed more fully. These are indicated in the plan's table of contents included in Appendix B.*

Issues/Key Questions:

- Who were the Maharajas?
- How did the riches of the Maharajas and their royal courts communicate their power and authority to their subjects? To outsiders?
- What did it mean to be a Maharaja? What did their personal and political lives entail?
- How was a country as large and complex as India ruled? How did the political landscape of India change over the past 300 years?
- How did British imperialism impact India and its Maharajas? Why and how did it end?
- What happened to the Maharajas in the 20th Century? Do they still exist today?
- How does Canada's history as a British colony differ from India's? How are Canadians connected to the Maharajas and their courts?

A second example, from the Walking Mountains Science Center plan, shows how that institution wished to convey the relationship of themes and visitor experiences for their exhibition project.

Themes

Excerpted from Walking Mountains Interpretive Plan and Concept Design, Avon, Colorado (2010)

Figure 6.3 shows how the Science Center elected to depict their exhibition themes and experiences. An example of their theme development follows.

Overarching Theme

Compelling Stories	Compelling Experiences
Water and Watersheds	Sense of Wonder
Land, Landforms, and Landscapes	Sense of Exploration
	Sense of Inquiry
Natural Science and the Scientific Method	Sense of Service
	Sense of Place
Community	Sense of Adventure
Cultural History and Perspectives	Sense of Empowerment
Sustainability	Sense of Stewardship
Green Building	Sense of Spirit

The Nature School Visitor Experience

Figure 6.3 Sample Theme and Visitor Experience
Organizer (adapted from Walking Mountains
interpretive plan 2010)

Overarching Theme:

Relevant and engaging experiences with nature are enjoyable and trans-formative; they stimulate our imagination, they teach us about place and relationships, they stimulate life-long curiosity, and they inspire us to be good stewards and citizens of the world.

Compelling Stories (or sub-themes based on this overarching theme):

• Water and Watersheds – If water is the lifeblood of the planet, then the watersheds of the globe are its veins and arteries; as such, stewardship of water and watersheds is critical for the survival of all living things.

• Community – Our planet, our country, our watershed, our ecosystem, or our backyard is simply a group of organisms sharing an environ-ment; at whatever scale, we humans are a community, a team charged with understanding, respecting and caring for this place and each other.

• Green Building – Because the built environment has a profound impact on our environment, health, and economy, conscious choices about energy, water, building materials, and waste are important to a sustainable future.

Continued with additional subthemes.

Compelling Experiences:

It is important that visitors to the school experience . . .

- A Sense of Wonder – where they make an emotional connection to nature that opens a door to curiosity and awe;
- A Sense of Inquiry – where they practice science inquiry through questioning, hypothesizing, testing/experimenting, critical thinking, and decision making;
- A Sense of Service – where they collaborate with others to make a difference in their own community.

Continued with additional visitor experiences.

 Part of becoming visitor-centric is thinking about planned activities or experiences from the visitor's perspective. In preparation for the Maharaja exhibition, the interpretive planner, in conjunction with the project team, developed a concept map (Figure 6.4) of what visitors would experience as they moved through the five zones of exhibition spaces and content. It was during the process of developing the map that the division into five zones was adopted.

Articulating desired visitor outcomes will help the planning team, and those who implement the plan, to better understand the intent of the actual on-site or in-person visitor experience; eventually, it will guide evaluation as well. Consulting the Outcomes Hierarchy (Figure 4.1) can be particularly helpful in this process of developing desired outcomes.

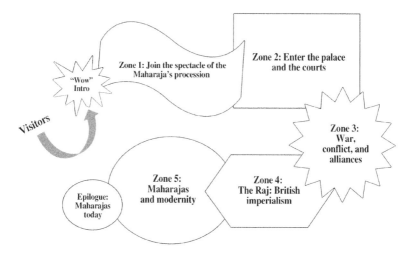

Figure 6.4 Concept Map of Maharaja Visitor Experience (adapted from Maharaja exhibition interpretive plan, AGO 2011)

Visitor Outcomes

Excerpted from Maharaja exhibition interpretive plan, Art Gallery of Ontario (AGO 2011)

Visitor Outcomes

- Visitors will explain the diversity and splendor of India's artistic tradition.
- Visitors will describe what it was like to be a Maharaja, giving three examples of both their personal and political lives.
- Visitors will compare relations between the British crown rule and the Maharaja to Canada's history as a British colony.
- Visitors will identify two ways that the traditional Maharajas' traditions, arts, and culture continue today, in Toronto and in India.

6.7. Recommendations

After developing and organizing the "storyline" or messages for the project, the planning team can begin to consider delivery options of the desired content and experiences. The team might consider:

- Could this part of the story be most effectively communicated through the use of video or ambient sound? How could we invite visitors to engage with the material?
- Can we design an installation so participants learn through discovery, rather than through didactic information?
- What do we want visitors to see, feel, and hear in this space? Can contextual information be provided through photographs or sounds?

 It is important that as much time is devoted to considering the potential modes of message delivery as to the development of the content. As the themes are developed into a robust set of linked messages, planners should consider questions such as:

- Which ideas would be best interpreted in an interactive?
- When is a video label featuring an artist discussing her work worth the added investment of money and staff resources?
- Which content should be migrated to the website for further exploration at home?
- When might a photograph or illustration communicate more clearly or effectively than words?
- Which ideas are sufficiently complex that they might be best presented in a lecture or program?

A review of the main messages, combined with diligent attention to the intended outcomes, will assist the interpretive planner in recommending

the most effective method, and the preferred rhythm of experiences, by which to deliver the project's content.

In some situations, in order to make final recommendations for a project, planners may find it useful to identify options for conveying messages, or various optional delivery systems. This process provides another opportunity to integrate audience input. Options can be reviewed with internal and external audiences to help inform final recommendations. If the team develops options as part of the project planning process, they should consider the following questions and the respective decision criteria (see sidebar, Criteria and Decision Making) for each alternative:

- Do the goals for the various options vary at all? How do the goals of each option align with the overall goals for the project?
- What is the overall approach for each option? How do the options each align with the proposed themes or key messages?
- What are the pros and cons of each option? What cost, time, or effort implications do each of the options have?
- What are the major design considerations for each option?

Criteria and Decision Making

All too often cost is used as the sole criterion in decision making. Planners will do well to consider the criteria below when deliberating about possible options.

- Mission: How well does this project align with our mission, vision, and overarching themes for education and interpretation?
- Recognition: What is the potential for this project to raise awareness about our institution?
- Reach: What is the potential for this project's reach? How many individuals, communities, or organizations might we influence with this effort?
- Impact (Visitor engagement): What potential does this project have for significant and desired impact on visitors or participants?
- Effort: What level of staff time and effort is required to plan, teach, and evaluate this project?
- Complexity: What is the level of complexity for developing this project?
- Expenditures: How much will this program, media, exhibit, facility cost to develop? To install? To maintain? To replace?
- Income (Cost recovery): How lucrative is this project, program, exhibition, activity, facility financially?

These criteria might be rated using a multiple-point scale or arrayed in a simple matrix for discussing and eventually deciding on the best option among several. It is not likely that all these criteria would be used for any one decision, but rather this list provides choices from which to select the most relevant criteria for any given decision.

 Formative evaluation is typically considered a strategy for testing prototypes during the design development process. However, where several alternatives for final recommendations are part of planning deliberations, the team may find that a formative evaluation strategy for gauging the merit of these ideas with potential audiences during planning may be appropriate. Once the preferred options are identified, planners can then develop them more fully for the final plan, although the full set of options, with decision criteria, should be included in an appendix of the plan for possible reference later.

After planners have weighed options and developed final recommendations, they should include the following information about each recommendation in the planning document:

- A brief description of the interpretive components of the project, with as much detail as needed so that the design development process can begin efficiently
- The intended theme and subthemes or key messages for project
- Specific intended visitor outcomes
- Any Americans with Disabilities Act or universal design requirements the project must meet
- Cost range for the various components of the recommendation

This section of the plan may also describe how the team expects final recommendations to be evaluated with sample audiences in a formative evaluation process.

Recommendations

Excerpted from the Maharaja Exhibition interpretive plan, Art Gallery of Ontario (AGO 2011)

The Maharaja plan treated each of the exhibit's five zones individually, expanding on key messages, associated visitor outcomes, and key objects. This was followed by a list of interpretive strategies, design and visitor experience strategies for that zone. We offer one zone as an example.

Zone 1: Royal Spectacle

Key Messages

- Who were the Maharajas?
- World of Maharajas and their rich culture
- Cultural and political role Maharajas played in the history of India
- Origins of word "Maharaja"—king above kings, great king
- Everything in the exhibition was commissioned by a Maharaja—role of Maharajas as patrons of the arts, and that their patronage reflected

power, chronicled the history/influence of the Maharajas and their relationships to other rulers/courts; relationship to their subjects, e.g. scroll paintings

Visitor Outcomes

• Visitors will feel like they are being warmly welcomed into another world to feel awe-inspired, excited and intrigued about what might lay beyond the introductory space.

Key Works

• Portrait of Maharaja Amar Singh, Object #1

Detailed Interpretive Strategies

• Title Wall with summary text
• Large map of India – include images of the palaces in the capitals and images of the kings
• Video – Introduction to India and Maharajas
• Audio – ambient audio in courtyard: whispering from windows, babbling water
• Interpretive Panel (Amar Singh Portrait, Object #1) – Text and diagram explaining significance of this portrait, and how, through symbols, Maharajas are identified as kings in art

Design/Visitor Experience Strategies

• Dramatic lighting, colour, fabric
• Bring elements of courtyard to entrance – windows, water feature. Have whispering in different languages to make it sound like there are people beyond the windows. Sound of water fountain (alternative to actual water). Gobos dappling light.
• Volunteer at the entrance to exhibit greeting visitors in traditional Indian fashion

Additional Recommendations (not zone-specific):

• Programming: Live performance in the exhibition will build on the success of "Drama and Desire" *[a previous exhibition]* and will communicate many of the project's key messages. An aggressive calendar of in-exhibition traditions of music and dance should be developed for weekend hours. *[Additional family events and adult programs were detailed here.]*
• Community Advisory Council: As the South Asian community is diverse and complex in itself, a community advisory council is recommended to assist staff in examining exhibition and program options and messages. This group is to be led jointly by the project manager and the deputy director of education, and is to understand its role as advisory and not decision-making, and not responsible for financial support, but rather to act as an advisory group and a source of community connections.

When final interpretive recommendations are described in a project interpretive plan, some planners find that including schematic drawings can aid in the eventual transition between planning and design development. Schematics can range from hand-drawn concept maps to artistically rendered images. They can be preliminary sketches that show the intent of recommended initiatives. Examples from the exhibition plan developed for the Hoover Dam Visitor Center (Figures 6.5a and 6.5b) show the kinds of schematics some planners use to envision the visitor experience.

Schematics can also be flow or bubble diagrams. The one shown in Figure 6.6 from the Maharaja plan helped in allocating space by theme for that exhibition.

Including schematics in an interpretive plan can be particularly useful if the plan will be enlisted as a development tool to seek funding or as a tool for communicating with board members, administrators, or community stakeholders about the specific intent of a project. Many planners feel that schematics are essential for helping others visualize a project as a three-dimensional experience. Indeed, a good image is worth a thousand words.

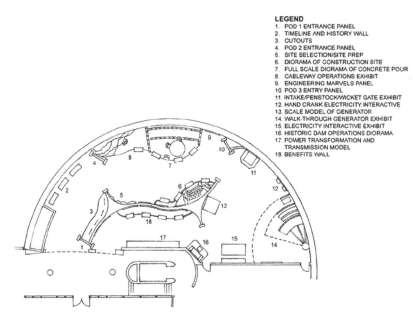

LEGEND
1. POD 1 ENTRANCE PANEL
2. TIMELINE AND HISTORY WALL
3. CUTOUTS
4. POD 2 ENTRANCE PANEL
5. SITE SELECTION/SITE PREP
6. DIORAMA OF CONSTRUCTION SITE
7. FULL SCALE DIORAMA OF CONCRETE POUR
8. CABLEWAY OPERATIONS EXHIBIT
9. ENGINEERING MARVELS PANEL
10. POD 3 ENTRY PANEL
11. INTAKE/PENSTOCK/WICKET GATE EXHIBIT
12. HAND CRANK ELECTRICITY INTERACTIVE
13. SCALE MODEL OF GENERATOR
14. WALK-THROUGH GENERATOR EXHIBIT
15. ELECTRICITY INTERACTIVE EXHIBIT
16. HISTORIC DAM OPERATIONS DIORAMA
17. POWER TRANSFORMATION AND TRANSMISSION MODEL
18. BENEFITS WALL

Figure 6.5a Floor Plan Schematic (reproduced from Hoover Dam Visitor Center interpretive plan, Bureau of Reclamation 2002)

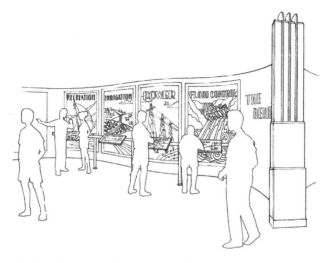

Figure 6.5b Elevation Schematic (reproduced from Hoover Dam Visitor Center interpretive plan, Bureau of Reclamation 2002)

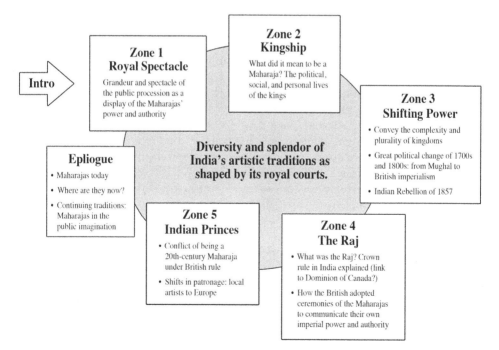

Figure 6.6 Sample Bubble Diagram Schematic (adapted from Maharaja exhibition interpretive plan, AGO 2011)

6.8. IMPLEMENTATION GUIDELINES

In planning specific projects such as programs, activities, or exhibits, often the most difficult consideration is knowing where the plan stops and implementation begins. The final part of the plan should serve as a transition to the implementation process and can be a good place to summarize costs by recommendation, propose a project timeline, speculate about materials or processes for implementation, and suggest visitor studies for testing design ideas or evaluating project results. The following checklist may be helpful in crafting the conclusion of the plan:

- Objects and photographs: What specific objects, artifacts, photos, images are needed for the exhibit or program? What is the expected process for image and object acquisition, including locating, obtaining proper authority, and acknowledging that source material? Are any special research materials related to objects, images, or photos needed for the project?
- Materials and supplies: Are there other particular materials or supplies required to implement the recommended initiative?
- Design ideas: Is there a general design standard for the project? Are there any general guidelines for design approach, materials, colors, construction, or eventual use that should be considered? Are there any special ADA specifications that should be recorded?
- Effort: In general, what are the steps, stages, or sequencing necessary for completing the work of the plan? Describing realistic effort or time estimates necessary for tasks such as research and writing, external image or object acquisition, conservation, graphic design, content development, evaluation and visitor studies, fabrication, and implementation is very important for successful design and development later. What level of in-house staff versus volunteer, consultant, or contractor personnel is necessary to implement the plan?
- Money: What are the proposed costs for the various components of the recommended project (or each of the alternative options)? Budget summaries might include estimates of design costs, production costs, and operation and maintenance costs, most often presented as cost ranges (see Figure 6.7). Estimated costs in the plan can later serve as reference points for staff and also for funders, contractors, or stakeholders.
- Timing/schedule and approvals: What is the proposed timeframe for implementing the plan's recommendations (see Figure 6.8)? Are specific approvals or processes required to complete the

Area	Estimated Costs
Orientation Areas and Transition Zones	**$80–90K**
Orientation Materials	$45–50K
Plaza and Walkway	$35–40K
Visitor Center Theater Complex	**$300–355K**
Theater Lobby	$50–55K
Theaters	$250–300K
Visitor Center Main Exhibit Hall	**$1,340–1,500K**
Visitor Center Main Exhibit Hall Preparation	$140–150K
Exhibit Hall Pod 1	$200–250K
Exhibit Hall Pod 2	$350–400K
Exhibit Hall Pod 3	$650–700K
Visitor Center Observation Areas	**$24–28K**
Visitor Center Observation Rotunda	$15–18K
Visitor Center Observation Deck	$9–10K
Original Exhibit Building	**$157–173K**
Exhibit Building Exterior	$2–3K
Exhibit Building Lobby	$35–40K
Exhibit Building Map Room	$120–130K
Subtotal	**$1,900–2,200K**
Design and Engineering (12%)	$220–260K
Exhibit Installation and Formative Evaluation	$140K
Contingency (10%)	$190–220K
Project Management (8%)	$150–170K
Project Total	**$2,600–2,990K**

Figure 6.7 Sample Budget Summary (reproduced from Hoover Dam Visitor Center interpretive plan, Bureau of Reclamation 2002)

plan and transition to implementation? How will the work of implementation be phased over time?

- Visitor studies: How will visitor studies or evaluation research be integrated in the design development, fabrication, and installation processes? What portion of time and budget should be allocated for those efforts?

Individual institutions will develop unique processes that support their culture. The Maharaja interpretive plan did not have a section

Month											
1	2	3	4	5	6	7	8	9	10	11	12
Research and Writing											
		Sign Design and Layout									
			Exhibit Design and Engineering								
					Fabrication						
								Install-ation			

Figure 6.8 Sample Simplified Time Scheduling Chart

titled "Implementation Guidelines," but several supporting documents were created as part of the exhibition development process. For example, meticulously prepared object lists were part of the project interpretive plan; these later evolved into detailed schematics and two- and three-dimension design images managed by the design department. All of the design drawings were later archived as part of the larger project. The museum also developed and implemented a full summative evaluation plan for this exhibition, filed the report as part of the project archive, and integrated the evaluation findings into future exhibition planning.

In the case of the Walking Mountains Science Center, planners prepared the project interpretive plan with a contract design firm, which then completed the design development for the project. An implementation guidelines section was included in the plan to ensure that assumptions were clear and to ensure that ideas would not be lost in the transition between planning and design.

Implementation Guidelines

Excerpted from Walking Mountains Interpretive Plan and Concept Design, Avon, Colorado (2010)

The purpose of this plan is to provide an overall vision, strategy, and thematic focus for the Science Center's educational and interpretive initiatives for the next five years and to recommend specific experiences, exhibits, and

programs for the new Buck Creek Campus. As desired and appropriate, the recommendations of this plan will soon be designed, fabricated, and installed in the design and development process *[as our Figure 6.9, based on the table in the plan, describes]*.

Planning (completed)	Design and Development	Fabrication and Installation
Site situation included background, history, and mission	Exhibit design drawings (DD1 and DD2)	Engineering drawings (CADD)
Need for plan	**Specific structural, lighting, materials, and finish recommendations**	Fabrication schedule
Purpose of plan		Demolition schedule (as appropriate)
Specific planning goals	Research and writing	Installation schedule
Inventory and analysis – resources and audiences (front-end evaluation)	**Graphic standard finalization**	Remedial evaluation (as needed)
Overall themes	Preliminary graphic design and layout for nonpersonal media	
Desired visitor experiences	Formative evaluation (as desired)	**Post Installation**
Media recommendations with schematic sketches and basic descriptions	Construction schedule and phasing	Maintenance and repair schedule
Preliminary budget and phasing recommendations	Detailed budget	Summative evaluation (as desired)
Implementation guidelines and transition to DD		

Figure 6.9 Sample Implementation Guideline Table (adapted from Walking Mountains interpretive plan 2010)

Some of the essential pieces of the design and development process shown in the table were then elaborated.

In sum, project interpretive planning is a process of convening a team of experts to deliberately and systematically think about visitor experiences and write down proposed ideas and decisions related to those deliberations. The process may take a week or a year depending on the scope and scale of the project—from a single program or activity to a large exhibition. As a written document, a project interpretive plan serves as an administrative record for project discussion and decisions, but it also describes the vision and direction for the project's intended impact.

Chapter 7

Concluding Thoughts

7.1. Revisiting Issues

In Chapter 1 we outlined five key issues in the informal learning field that we would address in offering an approach for interpretive planning and for integrating visitor perspectives within that process. In conclusion, we revisit these issues here.

Issue 1. Arbitrary Decision Making

As the opening story in this book illustrates, starting an exhibition process with an idea and an object list leaves many questions unanswered and may not provide sufficient information or rationale for suitable development or implementation. Changes in leadership, collections, or funding frequently stimulate decisions that derail projects from their original intent. Careful discussions and planning along with diligent integration of visitor perspectives into planning ensures the plan continues to connect the organization to the needs and interests of its visitors and its community. Plans are by their very nature unique and idiosyncratic; they must be flexible and will rarely be implemented exactly as originally written. A plan is, however, a road map and an administrative record; it serves to ensure the continued alignment of the museum's goals and the community's needs. An institution that develops and uses a deliberately devised, written plan dramatically increases the chances that their final products will achieve the desired impacts.

Furthermore, the fact that museums increasingly are becoming visitor-centric and taking visitor perspectives into account is evidence that the focus on visitors is expanding beyond simply measuring outcomes to informing planning. Indeed, consideration of visitor perspectives should be accepted as an integral part of planning. Planners who adopt a deliberate process of integrated interpretive planning

not only will reduce the chances of arbitrary decision making, but also will help focus their intentions and track the impacts of their efforts. Resources continue to evolve for those interested in learning more about the process. For example, the InformalScience website calls itself a *knowledge network*. Responding initially to the needs and interest in informal science education, it has expanded beyond that subject area and includes lists of members, research reports, and a "find an evaluator" section. Another useful Internet resource is www.visitorstudies.org.

Issue 2. Government Performance and Results Act (GPRA)

Like most other industries and organizations, museums are being asked to enhance accountability, improve efficiency, and provide evidence of impact. Likewise, funders are increasingly incorporating these demands into their requirements for funding requests. The more clearly a museum can demonstrate deliberate intentions toward accountability, efficiency, and effectiveness, the more likely it is to be successful. Therefore, adopting a process for planning visitor experiences that integrates visitor perspectives and articulates intended outcomes not only significantly helps demonstrate public responsibility but also helps establish the value of museums as a collective public good.

Issue 3. Leisure Time and Choice

More than two thousand years ago Heraclitus opined that the "only constant is change." Never has this seemed more true than today. With rapidly changing technology, demographics, and leisure choices, museums can easily become out of touch with the world around them. Interpretive planning helps institutions be diligent in reviewing their existing situation and in analyzing changing conditions and visitorship. Change is constant, and the constellation of leisure choices is likely to grow in size and complexity. By considering visitor perspectives and even broader social perspectives in planning, institutions can test their assumptions about what visitors want, and whether or not the programs offered resonate, engage, and have impacts as hoped.

Issue 4. Changing Paradigm of Education

Strides in technology have supported dramatic changes in our understanding of the field of neuropsychology, and these advances in research are beginning to reshape how we understand learning and teaching. In addition, cultural choices and norms around education are affecting how our audiences want and expect to learn. The Partnership for

21st Century Skills (www.p21.org) suggests that learning will continue to become even more learner-driven and lifelong. Museums can choose to play an essential role in this future, but in order to do so they must expand their understanding of the learning process.

The learning landscape of the future will likely change, perhaps significantly, from what it is today. Anticipating demographic changes, following the learning literature, and proactively planning with the future in mind will continue to be fundamental to museum practices. In addition, considering visitor and social perspectives in planning museum experiences—on line as well as in person—will need to become the norm if institutions are to stay abreast of broader changes in learning and education sectors.

Issue 5. Shrinking Dollars

As museums deal with stagnant or shrinking budgets, combined with expanding expectations, the challenge of balancing income and outputs can lead to diminished efficiency or effectiveness. However, museums that plan are more likely to remain efficient and effective. As we have discussed in this book, interpretive planning is the process of taking time to set a course for achieving intended goals. Museums that make time to plan—those who deliberately think about, discuss, and record their decisions about visitor experiences—are more likely to achieve their goals. Regardless of whether planning is at the regional, institutional, or project scale, interpretive planning helps museums map out their intentions and provides them with a document that can be held up in front of boards, funders, and community leaders to show accountability and to provide a touchstone for evaluation.

Stephen Weil (2002) noted that outcomes are the profit currency of the nonprofit industry. Most private sector organizations would not consider new product development without consulting their consumer base. Ever since Jan Carlzon (1987) inverted the management paradigm and coined the term "moments of truth" to describe the crucial interface with customers, many commercial businesses have become customer-centric in their management. Museums have an obligation to do the same. Identifying and analyzing visitor perspectives and integrating them into interpretive planning ensures that our "customer" is recognized and that our projected impacts are well considered and realistic.

In summary, as we stated in Chapter 1 in this book we acknowledge the need for more deliberate decision making that embraces deeper, more analytical thinking among museum professionals. We also are compelled to restate and reinforce the concept that to understand accountability and outcomes is to better conceive programs that achieve intended impacts.

In addition, we recognize that the populace faces tough decisions about allocating precious leisure choices and how important museums are in that constellation of choices. We also recognize that transformations in education and learning are underway and museums need to position themselves in the midst of a learning landscape for the new millennium. Finally, with funding tight and funding agencies insisting on increased accountability and transparency, staking a strong and central evidence-based claim about the public value of museums is important for their economic sustainability.

7.2. OUTCOMES, IMPACT, AND PUBLIC VALUE

As we described in Section 4.2, over time attention to outcomes can provide a body of evidence that demonstrates impact, and hence public value. This work is gradually building a data bank of our individual and collective impacts on learners and communities. Individual museums too can become involved in this broader discussion. Many communities are collaborating to further define indicators of cultural richness and health, including the role of museums as facilitators of learning, creativity, and discovery in contributing to overall community vitality and viability.

In Philadelphia, the Urban Institute led an effort to describe the impacts that cultural organizations have on their communities through a program called Culture, Creativity and Communities. In their publication *Progress in Arts and Culture Research: A Perspective*, Maria Rosario Jackson wrote:

> Without a better grasp of how arts and cultural activity can and do shape communities, planners and policymakers cannot do their best work. With better data and analysis, we are making strides in integrating arts and culture as a core topic alongside and within other areas of concern like education, community development, and health. We have come a long way and there is much more to be done, but the assumptions that arts and culture are limited to downtowns, that the only impacts that matter are economic impacts, and that arts and cultural activity are at the periphery of community life rather than at the core are fading as our grasp of how communities actually work and change comes into sharper relief. (Jackson 2008, 2)

The project allowed the city of Philadelphia to develop shared cultural indicators as outlined in the Urban Institute's report *Cultural Vitality in Communities: Interpretation and Indicators* (Jackson, Kabawasa-Green, and Herranz 2006). It continues to measure cultural investment, participation, and impact across sixteen categories ranging from community

diversity to school quality to the environment and arts and culture. Within the last category, the project captures data for indicators such as attendance (both numbers and audience makeup), employment, breadth of funding, and the geographic distribution of cultural organizations. The work results in an annual report that helps the city in assessing the impact of their cultural sector, as well as in imagining what the ideal impact might be.

In the museum sector specifically, over the past decade, "public value" has been the theme of numerous related professional association annual meetings and professional journal articles. Carol Scott (2006) has written extensively about the changing role of museums and their place in society, and their struggle to define *worth* and *public value* in Britain and Australia as well as the United States. New governmental policies in Britain and Australia outline the need for museums to offer evidence that they "make a difference" and have long-term social impacts. Scott wrote that

> evaluation is fundamentally about assessing the worth of something against criteria. This raises the question of whose values are being applied. In the recent past, the values have been those of economic rationalism. Currently, they centre on government priorities related to increased access and equity, greater social cohesion and improved societal well-being. Worthy though these social goals may be, do they reflect the extent of outcomes and impact resulting from museum activity, especially those that are intangible, affective and thus hard to quantify? Further, do they reflect the reasons that society values museums? (Scott 2006, 69)

In a subsequent article Scott wrote:

> Future evaluation models will need to be aligned with a values-based paradigm, if value is to be the basis on which we argue the significance of the sector to governments and other stakeholders. What will be non-negotiable, in an environment of continuing results-based accountability and declining public spending within a time of economic constraint, is the need for evaluation to justify continued investment from the public purse on the basis of robust evidence that this investment produces value for the public. (Scott 2009, 197–98)

Scott goes on to present a study she completed in Australia that explored the question of why and how communities value their museums from the perspectives of both the shapers (museum professionals) and the consumers (the general public). The study revealed that, particularly from the perspective of the public,

> the important impacts of museums are the "intangibles"—the personal learning in a visual, hands-on, free-choice environment, the development

of perspective and insight and the important experience of linking with the past. This is the language of impact and value emerging from the "heart and purpose" of museums and the experience that they create. It goes some way to describing the "worth" of museums in terms that we share. (Scott 2009, 70)

This study resulted in the identification of categories of potential indicators of public value for individuals and communities (see sidebar, Indicators of Museum Value); and, whereas Scott's indicators are primarily numeric, she is asking us to consider more than just attendance and door receipts as we analyze the impact of our efforts. Describing impact includes describing outputs, but as the United Way task force (Hatry et al. 1996) reminds us, it is also about considering the change or transformation in visitors (outcomes) as a result of their experiences. We encourage readers to consider both outputs and outcomes when integrating visitor perspectives in planning, as both build toward ultimate impact.

Indicators of Museum Value (from Scott 2009, 201–3)

Indicators of Use Value

Direct use (physical visits)
- Number of visitor attendances to museums annually

Indirect use (use of outreach services)
- Number of users of outreach programs, i.e., number of participants to traveling exhibitions outreach programs including lectures and workshops
- Number of unique visits to museum websites

Engagement
- Number of volunteers
- Total number of volunteer hours per annum
- Number of members
- Number of unpaid hours contributed by Boards of Trustees, fundraising groups, etc.
- Number of visits per visitor per year

Non-use
- Willingness to pay irrespective of direct engagement

Indicators of Institutional Value

Recognition of trusted expertise
- Number of public enquiries annually
- Number of external projects for which museum expertise has been requested

Building relationships
- Number of local, national and international partnerships involving museums and other government agencies
- Significance of these projects in terms of $, number and type of major stakeholders

Attracting investment
- Value of government grants (capital and recurrent)
- Number and value of sponsorships (cash and in kind)

Capacity to bequests and donations
- Number and value of donations
- Number and value of bequests

Indicators of Instrumental Value

Providing educational resources
- Number of school students visiting
- Number of partnerships with education bodies
- Number of adult education programs/participants

Knowledge building
- Number of research publications based on collections
- Number and value of museum/university projects funded by Research Grants

Contribution to tourism
- Number of domestic tourists annually
- Number of international tourists annually
- Number of museums that win tourism awards annually

Contribution to local economy
- Number of full-time equivalent employed staff
- Value of local services purchased

Social inclusion
- Number and percentage of visitors by ethnicity
- Number and percentage of visitors by socio-economic status

Scott's work on value indicators was further explored by the Columbus Art Museum, Columbus, Ohio, which developed and tested the reliability and validity of an instrument to measure each indicator and hence to capture public value (Yucco et al. 2009). Under the direction of Joseph Heimlich, the museum developed and tested an instrument at community art festivals, engaging both visitors and nonvisitors. Nineteen instrument items asked participants to consider the role of the Columbus Art Museum on issues that included, but were not limited to, the provision of a safe space to meet people of diverse backgrounds, a

source of information, a contributor to the local economy, and a source of pride for citizens. The study verified the existence and measurability of the individual, societal, and economic categories and affirmed that the findings of such research could be used to shape the museum's communication efforts with local stakeholders. More recently, Heimlich has used this instrument with six Ohio accredited zoos to explore if, and how, each community values its local zoo. Interestingly, while each community holds great pride in its zoo, the communities that have been seriously affected by the recent economic downturn more highly valued their zoo's economic contributions to the local economy (personal communication, J. Heimlich, June 9, 2012).

Indicators of public value have also been described and mapped by Brown (2006), who arranged five clusters of arts benefits on the two axes of time of engagement, including exposure both across time and across repeated visits, and recipient, from the individual to the community level (Figure 7.1a). The areas of benefits he describes fall into five categories, beginning with an "Imprint of the arts experience" (lower left) and expanding with repeated and expanded exposure to

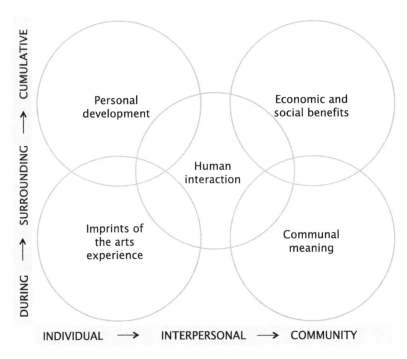

Figure 7.1a Five Clusters of Benefits (adapted with permission from Brown 2006)

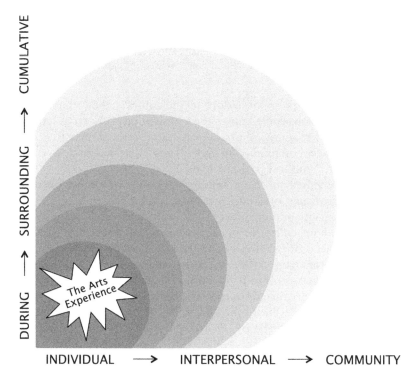

Figure 7.1b A Map of Art Experience Benefits (adapted with permission from Brown 2006)

personal development, human interaction, communal meaning, and economic and social benefits. Brown developed this map with the intention that if arts organizations had a strong and shared framework to define and measure their impact, they would build more coherent and compelling case statements, support the work of emerging artists, and even support community cultural planning (Brown 2006, 3; see Figure 7.1b).

Brown goes on to state:

> I hope for a time when board members of arts organizations sit down on a regular basis with both administrative and artistic staff and talk about the benefits they seek to create for their communities. . . . Clearer language and a better framework for discussing benefits will help boards to exercise their purview over artistic output at an appropriately high level. . . . I envision a time when a "value audit" is an integral part of an organization's report card to the community, and when community representatives are regularly consulted about what benefits they seek from an organization

that exists, ostensibly, for public benefit. . . . In the very largest sense, a new framework might serve as the basis for a new approach to community cultural planning, an approach that takes stock of cultural resources in terms of the benefits they create and helps to identify gaps in the system. (Brown 2006, 21–22)

Finally, much work has been done on indicators as they relate to how cultural organizations contribute to the sustainability of society. Douglas Worts (2010) offers a critical assessment framework, similar to Scott's, but with a stronger community focus, to act as a decision guide to ensure that multifaceted cultural goals are considered.

Beyond individual museums building evidence of impact over sustained periods using outcome measures, and beginning to explore methods to measure and document their individual public value, a new conversation about collective impact is emerging. According to Kania and Kramer (2011, 36), collective impact is the "commitment of a group of important actors from different sectors to a common agenda for solving a specific social problem." Examples of collective impact projects range from youth organizations working together to support struggling schools to a citywide effort in Somerville, Massachusetts, to reduce and prevent childhood obesity. Project partners in the latter example included Tufts University, government officials, educators, businesses, nonprofits, and citizens, who collectively defined wellness and weight gain prevention practices, and the role each might take to support the shared goal. Kania and Kramer go on to suggest that nonprofits' current tendency to operate using an approach they call "isolated impact" results in organizations often "working at odds with each other and exponentially increasing the perceived resources required to make meaningful progress" (Kania and Kramer 2011, 38). These authors encourage nonprofit organizations to work collaboratively, with a shared agenda, shared measurement systems, mutually reinforcing activities, continuous communication and a single organization in a coordinating role, to increase efficiency and efficacy in responding to community needs. This process relates directly to the discussion of regional interpretive planning described in Section 3.2, where we emphasize the importance of considering the community's needs and the participating partners' perspectives.

7.3. Twenty-First-Century Planning

Our purposes in writing this book were to highlight the notion of outcomes and impacts related to visitor experiences in museums, to offer an approach for planning visitor experiences in museums, and to discuss the integration of visitor perspectives in interpretive planning and

Figure 7.2 As the (Museum) World Turns . . .

decision making. As Figure 7.2 illustrates, the museum has not been a static entity. We aim to inspire museums to remain dynamic as they conceive, plan, and develop appropriate and meaningful visitor experiences. Furthermore, it is our hope that the ideas proposed here encourage increased attention to interpretive planning in and for museums and that those plans will contribute to the body of work (and a community of practice) that helps document the impact and value of museums. We trust that enhanced focus on visitor perspectives will result in increased numbers of people who see themselves reflected in museums—all types of museums—and that, at the same time, museums will begin to recognize and tout the tremendous value they hold for education and learning.

The intent here was not to propose a single approach to planning that would impede or compete with creative processes that currently exist in most museums. Although this book summarizes some of the key features of visitor perspectives and interpretive planning, we do not intend it to be exhaustive. At a minimum, we have endeavored to contribute to a shared vocabulary and better practices in museums. We hope that this attempt to describe and exemplify interpretive planning for museums, one integrated with visitor perspectives, will stimulate an interest in collaborative efforts for thinking about and recording decisions related to visitor experiences. We are confident that many more examples of museum interpretive plans will be appearing in the coming years.

Appendix A

EXAMPLE OF OUTCOMES HIERARCHY USED AS AN EXECUTIVE SUMMARY OF VISITOR PERSPECTIVES

To further exemplify the utility of the Outcomes Hierarchy (see discussion in Chapter 4) we offer an example here of the hierarchy used as an executive summary or a visual record of the results of many hours of research and discussion. Description of the information regarding each of the tiers of the hierarchy is presented below from bottom to top, as the triangle is constructed, building from the preparatory collection of data on the bottom to the ultimate impact of the project at the top.

Hypothetical Project: Anthropology Exhibit

An interactive, immersive exhibit that interprets the interaction between human biology, culture, and the natural environment through time; i.e., evolution.

Audience Data and Information

Psychographic Data: (a) Misconceptions: e.g., humans are not animals; offspring inherit adaptive changes from their parents; humans are the culmination of evolution; evolution is only a theory; evolution is a teleologically

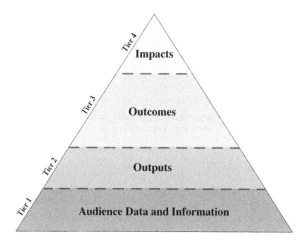

Figure A.1 Outcomes Hierarchy Basic Structure

driven process; evolution is a single line from simple to complex; Africa is evolutionarily inferior to Europe; (b) Knowledge and Attitudes: more than 50 percent of the population are either unsure of or reject the idea of evolution.

Descriptive Data: (a) Primary audience: community residents and visitors (primarily visitors over age 10); university/academic community; (b) Secondary audience: families, school students and teachers (grades 5–12); (c) Tertiary audience: national/international audience via traveling exhibit and interactive Internet site.

Outputs

People: expected annual attendance: public = 50,000; school groups = 50 classes (x 25/class); other = 4,000.

Programs: four distinct community/family programs offered once per week; speaker programs offered one per month; guided tours for school groups hosted weekly; teacher enhancement program held twice per year.

Products: gallery exhibition, traveling exhibition, gallery guide, interactive Internet site, FAQ brochure, supplemental reading list, visitor feedback survey.

Outcomes (General summary)

Immediate: Visitors will think like scientists; confront misconceptions and their sources; explore how environmental forces have shaped human development; demonstrate excitement about science; gather and analyze data in exhibit examples; discuss and exchange ideas with others.

Short-Term: Visitors will remember and use some of the facts from the exhibition; read books, watch TV, and have family conversations on the topic; have more confidence in their opinions related to the topic.

Long-Term: Visitors will remember and use some of the facts presented; retain and use the scientific method when appropriate; read scientific articles in newspapers and magazines; and become an advocate for teaching human evolution.

Impacts

Visitors will participate in community activities that support quality science education and the teaching of evolution.

We present the Outcomes Hierarchy as a conceptual framework, however, and not as a fill-in-the-blank tool. This example presents a broad, general summary of what visitor perspectives of a hypothetical

interpretive project might look like when considered all together. In this format it might be used to communicate with funders about the overall intent of a project, or by managers to capture the spirit of a project. Creating an executive summary using the structure of the Outcomes Hierarchy is useful, but, as discussed in Chapter 4, the hierarchy's true contribution lies in assisting planners in framing the kinds of questions institutions need to ask themselves and their audiences if they are to stay relevant and connected to their community. In the case of a master interpretive plan, the research and deliberation required to answer those questions may take the better part of a year (see Chapter 5); for a project interpretive plan, the same process might take several weeks or months (see Chapter 6).

Appendix B

Sample Tables of Contents of Interpretive Plans

This appendix contains examples of tables of contents from different interpretive plans—two project interpretive plans, followed by three master interpretive plans—that illustrate the diverse formats and organizations of plans. Details from some of them appear in the examples that we discuss in Chapters 5 and 6.

1. Project Interpretive Plans

Example 1. Maharaja: The Splendour of India's Royal Courts, Art Gallery of Ontario, Toronto, Canada (2011). *[This plan consisted of collateral foundational documents plus the document outlined below.]*

I. Overall Interpretive Summary
 a. Big Idea
 b. Issues/Key Questions
 c. Visitor Outcomes
 d. Overall Key Messages

II. Exhibition Zones/Key ideas
 a. Intro/ Royal Spectacle
 b. Kingship of India
 c. Shifting Power
 d. The Raj
 e. Princely India

III. Schematic of Exhibition Zones/Key Ideas

IV. Concept Map of the Visitor Experience

V. Introduction
 a. Introduction
 b. Key Messages
 c. Visitor Outcomes
 d. Key Works
 e. Detailed Interpretive Strategies (text, AV, human animation, etc.)
 f. Design/Visitor Experience Strategies

VI. Zone 1: Royal Spectacle
 a. Introduction
 b. Key Messages
 c. Visitor Outcomes
 d. Key Works
 e. Detailed Interpretive Strategies (text, AV, human animation, etc.)
 f. Design/Visitor Experience Strategies

VII. Zone 2: Kingship of India
 a. Introduction
 b. Key Messages
 c. Visitor Outcomes
 d. Key Works
 e. Detailed Interpretive Strategies (text, AV, human animation, etc.)
 f. Design/Visitor Experience Strategies

VIII. Zone 3: Shifting Power
 a. Introduction
 b. Key Messages
 c. Visitor Outcomes
 d. Key Works
 e. Detailed Interpretive Strategies (text, AV, human animation, etc.)
 f. Design/Visitor Experience Strategies

IX. Zone 4: The Raj
 a. Introduction
 b. Key Messages
 c. Visitor Outcomes
 d. Key Works
 e. Detailed Interpretive Strategies (text, AV, human animation, etc.)
 f. Design/Visitor Experience Strategies

X. Zone 5: Princely India
 a. Introduction
 b. Key Messages
 c. Visitor Outcomes
 d. Key Works
 e. Detailed Interpretive Strategies (text, AV, human animation, etc.)
 f. Design/Visitor Experience Strategies

XI. Epilogue: Maharajas Today
 a. Introduction
 b. Key Messages
 c. Visitor Outcomes

 d. Key Works
 e. Detailed Interpretive Strategies (text, AV, human animation, etc.)
 f. Design/Visitor Experience Strategies

XII. Additional Recommendations (not zone-specific)

Example 2. Hoover Dam Visitor Center and Grounds Interpretive Plan (Bureau of Reclamation 2002)

Situation Overview

- Site Description
- Need for Plan
- Plan Purpose, Goals, and Scope

Visitor Opportunities and Project Themes

- Audience Considerations
- Desired Visitor Experiences
- Project Areas and Themes

Orientation Area and Transition Zone

- Visitor Center Theater
- Visitor Center Exhibit Hall
- Visitor Center Observation Area
- Original Exhibits Building
- Personal Interpretation

Administration and Logistics

- Budget Summary
- Implementation Tasks
- Sequencing

Appendices

- Sample Period Art Work
- Example Sign Panel Designs
- Sequencing Tables

2. MASTER INTERPRETIVE PLANS

Example 3. Education and Interpretive Master Plan for Coastal Maine Botanical Gardens, Boothbay, Maine (CMBG 2008)

Preface

- How to Think about this Plan
- How to Use this Plan
- Most Useful Pages in this Plan

Section I: Introduction

- Overview of the Organization and the Site
- Need for and Purpose of this Plan
- Planning Considerations
- Organization of this Plan

Section II: Resource Inventory and Analysis

- Garden Sites and Facilities
- Garden Plans and Planning Efforts
- Existing Interpretive/Educational (I/E) Staffing, Programs, and Media
- Audiences

Section III: Site Themes and Vision for the Visitor Experience

- Overall Site Themes
- A Vision for the Visitor Experience
- Desired Visitor Outcomes
- Key Garden Experiences

Section IV: Staffing and Visitor Monitoring Recommendations

- Recommended Staffing Levels
- Staffing Position Descriptions and Qualifications
- Other Staffing Considerations
- Visitor Segmentation and Monitoring

Section V: Interpretation/Education Program and Media Recommendations

- Interpretation and Education Program Priorities
- Non-Personal Media Recommendations
- Personal Program Recommendations
- School Program Recommendations
- Special Event Recommendations
- Outreach Recommendations
- Suggestions for Visitor Studies and Evaluation

Section VI: Implementation Guidance

- Transition Comments and Recommendations
- Post-Planning Implementation Guidance
- Resources for I/E Training

Appendices

- Appendix A: Program and Media "Wish List" Planning Worksheet
- Appendix B: Various Types of I/E Media Defined and Described
- Appendix C: Table of 2007 CMBG Programs
- Appendix D: Site Signs Suggested by Site Committee - March 2007
- Appendix E: Developing Visitor Engagement and Outcomes

Example 4. Walking Mountains Science Center Interpretive Plan and Concept Design, Avon, Colorado (2010)

Section 1: Introduction

1.1. Walking Mountains Science Center
1.2. Purpose of this Plan

Section 2: Current Situation: Staffing, Programs, and Resources

2.1. Staffing and Organization
2.2. Existing Education Planning Efforts
2.3. Current Education Programs
2.4. Program Participation and Evaluation
2.5. Existing Educational Resources
2.6. Analysis

Section 3: Audience Inventory and Analysis

3.1. Audience Inventory Included in the Walking Mountains Business Plan
3.2. 2009 On-site Group Discussion Data
3.3. Demographic Data
3.4. Recent Barriers Research with Hispanic Audiences
3.5. Analysis

Section 4: Overarching Themes, Experiences, and Institutional Philosophies

4.1. The Buck Creek Campus Experiences
4.2. Overall Desired Visitor Outcomes
4.3. Overarching Themes
4.4. Institutional Philosophies

Section 5: Buck Creek Campus Media Recommendations

5.1. Outdoor Interpretive Media
5.2. Indoor Interpretive Media
5.3. Non-Thematic Media
5.4. Future Interpretive Considerations

Section 6: Program Recommendations

6.1. Program Organizer
6.2. Criteria and Program Decision-Making
6.3. Staffing Recommendations
6.4. Program Tracking, Monitoring, and Evaluation

Section 7: Implementation Recommendations

7.1. Phasing and Schedule
7.2. Cost Summary
7.3. Transition to Design-Development and Fabrication

Appendices

 A. Glossary of Terms and Acronyms
 B. Points of Consensus
 C. Education Plan (2007)
 D. Helpful References
 E. Current and Desired Future Program Descriptions
 F. September 2009 Discussion Group Summary

Example 5. Copper Country National Byway Master Interpretive Plan for the Copper Country Trail National Byway Committee and the Western Upper Peninsula Planning and Development Region (WUPPDR), Houghton, Michigan (2011)

Section 1. Introduction

 1.1. National Scenic Byway Program
 1.2. Copper Country Trail National Byway
 1.3. Interpreting CCTNB
 1.4. Need for and Purpose of this Interpretive Plan
 1.5. Terms and Definitions
 1.6. The Planning Process
 1.7. Planning Considerations

Section 2. Current Situation (Supply) – Resource Inventory and Analysis

 2.1. Planning Efforts Related to the Byway
 A. Pre-Byway Planning
 B. Byway Planning
 C. Related National Park Service Planning

 2.2. Inventory of Byway Assets
 2.3. Stakeholders of the Byway
 2.4. Tourism Literature of the Byway Region
 2.5. Signs, Wayshowing, and Wayfinding
 A. Developing Effective Wayshowing for Byways
 B. Summary of Wayshowing Visitor's Eye Canvas for CCTNB

 2.6. Road and Sign Documents – MDOT and CCT
 A. All Roadsides Are Not Created Equal
 B. Wayfinding and Signage Strategy for State Heritage Routes
 C. Copper Country Trail: Corridor Wayfinding Inventory
 D. Preserving the Character: A Visual Assessment
 E. Keweenaw National Historical Park Sign Plan

Section 3. Current Situation (Demand) – Visitor Inventory and Analysis

3.1. Summary and Analysis of Existing Audience Inventories (Secondary Data)
A. Keweenaw Convention and Visitors Bureau
B. Fort Wilkins and McLain State Park Visitor Data
C. Michigan State Comprehensive Outdoor Recreation Plan
D. Keweenaw and Houghton County Census Data
E. KNHP Visitor Study
F. Keweenaw Marketing, Demand, and Feasibility Studies

3.2. Front-End Evaluation Summary Results and Implications (Primary Data)

Section 4. Interpretive Themes and Visitor Experiences

4.1. Project Vision and Traveler Goals
4.2. Themes and Compelling Stories
4.3. Traveler Experiences and Desired Traveler Outcomes

Section 5. Interpretive Recommendations

5.1. Terms and Definitions used in the Recommendations
5.2. Priorities and Decision Criteria
5.3. Media Recommendations
A. Byway Maps
B. Gateway and Terminus to the Byway
C. Signs and Turnouts by Byway Segment
D. Travel Portfolio and Printed Interpretive Media
E. Collaboration and Training
F. Electronic Media and Social Networking
G. Other Media and Materials

Section 6. Implementation Guidelines

6.1. Summary of Recommendations with Budget Considerations
6.2. Sequencing Summary
6.3. Transition to Design Development and Fabrication
6.4. Helpful Resources

Appendices
A. Byway Assets Checklist
B. Evaluation Reports
1. Front-End Evaluation Report
2. Formative Evaluation Report
C. Resource Matrix

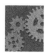

Notes

1. July 2001 at the conference of the Association of Botanical Gardens and Arboreta (now called the American Public Gardens Association).
2. The Museum Services Act defines a museum as "a public or private non-profit agency or institution organized on a permanent basis for essentially educational or aesthetic purposes, that utilizes a professional staff, owns or utilizes tangible objects, cares for the tangible objects, and exhibits the tangible objects to the public on a regular basis. Such term includes aquariums, arboretums, botanical gardens, art museums, children's museums, general museums, historic houses and sites, history museums, nature centers, natural history and anthropology museums, planetariums, science and technology centers, specialized museums, and zoological parks." (Manjarrez et al. 2008, 3)
3. The American Alliance of Museums reports at least 17,500 museums (askville.amazon.com/Museums-United-States-America/AnswerViewer.do? requestId = 32245578. Accessed October 1, 2012); Kratz and Merritt (2011) report 24,000 museums in the United States.
4. Summaries of other works by Robinson on visitor studies can be found in *Visitor Behavior* 3(1):4.
5. *ILVS Review* was published by Chan Screven and H.H. Shettel of the International Laboratory for Visitor Studies (ILVS) at the University of Wisconsin–Milwaukee.
6. The Yosemite Museum, designed by architect Herbert Maier and constructed in 1925, was the first building built as a museum in the national park system. Although its educational initiatives served as a model for parks nationwide, it was not until 1965 that national guidance for interpretive planning in the park service emerged.
7. In Great Britain, the term *generic learning outcomes* is used to describe outcome categories that include knowledge and understanding; skills; attitudes and values; enjoyment, inspiration, and creativity; and activity behavior and progression (Hooper-Greenhill 2007).
8. Different disciplines and organizations have developed different conventions of usage for the terms *outcomes* and *impacts*. For example, in one common usage outcomes are changes in the learner shortly after participation; impacts are longer-term changes in the learner; and benefits are changes at a community or societal level as a result of impacts on individuals.

GLOSSARY

Affective domain. Area of learning involved with attributes of human experience that describe feelings and emotions and sometimes attitudes or values; often used to describe one area of learning outcomes. (See also Cognitive domain, Psychomotor domain, Social domain, Table 4.2.)

Assessment. Measurement of a learner's performance; the process of documenting, usually in measurable terms, knowledge, skills, attitudes, and beliefs; a term used frequently in formal education contexts.

Audience. The group of people who are the targets for participation in a museum's events, programs, or activities; can include both current and potential visitors.

Audience research. Systematic gathering of information (descriptive, psychological, contextual) about visitors or audiences. (See also Demand analysis.)

Benefit, Benefits. Lasting, meaningful change over time that results from multiple and diverse learning experiences; refers to collective sociological, psychological, economic, and environmental impacts of education and learning, often at a community level; often used interchangeably with the term long-term impacts.

Cognitive domain. Area of learning involved with attributes of human experience that describe knowledge, belief, facts; often used to describe one area of learning outcomes. (See also Affective domain, Psychomotor domain, Social domain, Table 4.1.)

Critical appraisal. Evaluation of the overall evidence-based observations and expert judgment concerning an exhibition, program, or interpretive product by a professional evaluator, seasoned museum practitioner (or panel of same) in order to identify obvious or suspected problems that may hinder the effectiveness of the program or product.

Demand analysis. Deliberate and systematic gathering of information and data about past, current, and potential audiences for planning and administrative decision making. Audience inventory and analysis considers past, current, and future perspectives in order to understand and describe patterns in the data when making planning recommendations. (See also Audience research.)

Education. An act or experience that has a formative effect on an individual's mind, emotion, or behavior; the formal process by which society deliberately

transmits its accumulated knowledge, skills, customs, and values from one generation to another. (Compare Learning.)

Formal education. Education that takes place in a planned way at recognized institutions such as schools, colleges, universities, museums. A teacher mediates learning in a formal setting, and the student generally follows the teacher's or leader's agenda. Motivation for learning is extrinsic to the learner (e.g., parent, society). The teacher's goal is to impart knowledge, and the learner's goal is to increase his or her knowledge and skills.

Nonformal education. A planned but highly adaptable form of instruction that is mediated in some way but in which the motivation for learning is intrinsic to the learner (e.g., Elderhostel, organized field trips and museum visits, Girl Scouts, Boys and Girls Clubs, 4-H Clubs). The goals of the learner may include increasing skills and knowledge but may also include emotional rewards that flow from an increased enjoyment with the topic or an increased passion for learning as a result of the activity.

Informal education. Learning opportunities that are both voluntary and self-directed; the learner is motivated intrinsically, and there is no moderator or authority figure. May occur spontaneously in everyday situations, within the family, or in the neighborhood, wherever there is opportunity for personal exploration or discourse; can stimulate learning in all domains: cognitive, affective, psychomotor, and social.

Evaluation. As used in visitor studies, the study of something to determine its feasibility and effectiveness; the systematic collection and interpretation of information about the effects of exhibitions or programs on visitors for the purpose of decision making.

Evaluation research. Gathering of data to help guide judgment of worth or merit related to programs or exhibits. Distinguished from evaluation in that it is typically supported by a theoretical or conceptual framework and follows a rigorous and systematic methodology in which data are generalizable to broader contexts beyond the study area or sample.

Exhibit. A selected component subsection of a larger exhibition; typically addresses a single topic or theme.

Exhibition. A cohesive assemblage of displays or exhibits designed around a common concept or theme.

Exhibit design, Exhibition design. The process of conceiving exhibits, exhibitions, or interpretive media (interactive and otherwise) for conveying educational content and creating an engagement or learning opportunity. Often involves a group that may include content experts, educators or interpreters, researchers, writers, fabricators, evaluators, and sometimes administrators.

Exhibit development, Exhibition development. The process by which an exhibit or exhibition design becomes reality; involves the fabrication or implementation of exhibits or exhibition components that are designed to convey planned content.

Formative evaluation. Testing of an exhibit or concept to help determine the appropriateness of design, effectiveness of exhibit communication, and use by visitors. The process aids in checking assumptions during the exhibition development process, and findings from formative evaluation are typically used to make changes that improve the design of a program or exhibit or enhance the visitor experience.

Front-end evaluation. Audience or visitor research integrated into interpretive planning or media development; employed in the conceptual or early interpretive planning stage to better understand the audience's entrance narratives.

Goal. In museum planning, a broad, general statement about the purpose or intent of an interpretive project or exhibit.

GPRA. Government Performance and Results Act (1993), one of a series of laws designed to improve government project management. Requires agencies to engage in project management tasks such as setting goals, measuring results, and reporting progress.

Impact. The effect or impression of one thing on another. In interpretive planning, impacts are one type of outcome; typically refers to the collective long-term effect, benefit, or outcome of a visitor experience.

Indicator. A benchmark or specific performance target used to determine success of an outcome; sometimes referred to as a performance measure.

Interpretation. (a) In a curatorial context: the act of parsing meaning from text, objects or artworks, actions or traditions. (b) In an educational context: the collective set of informational, interpretive, and educational materials, programs, exhibits, media, and facilities that serve to enhance the visitor experience in museums and informal learning settings. (c) An educational activity that aims to reveal meanings and relationships through the use of original objects, by firsthand experience, and by illustrative media, rather than only to communicate factual information (Tilden 1957). (d) A mission-based communication process that forges emotional and intellectual connections between the interests of the audience and meanings inherent in the resource. (National Association for Interpretation 2007).

Interpretive planning. A deliberate and systematic process for thinking about, deciding on, and recording in a written format or plan educational and interpretive initiatives for the purpose of facilitating meaningful and effective experiences for visitors, learning institutions, and communities, where,

- *deliberate and systematic* means that the process is intentional, thoughtful, and methodical;
- *process* refers to an ongoing and enduring course of action, a procedure that embraces change and opportunity;
- *thinking* means that the planner (individual or team) exercises the power to reason in order to arrive at judgments or decisions; *thinking* also encompasses deliberating with others who are involved in the process;
- *deciding* means engaging in a process of decision making in which the planners, in collaboration with or influenced by other people,

organizations, and entities who may be affected by the plan, come to a determination about provisions in the plan;

- *recording* means communicating in written form (print or electronic) the deliberations, decisions, and other provisions of the process in an organized and reasonable manner;
- *plan* refers to the document (which may be a digital text file) that serves as an administrative record of the planning effort;
- *educational and interpretive initiatives* refers to the activities and projects (e.g., exhibits, programs, educational media, outreach) that attract, engage, teach, and inspire visitors;
- *purpose* refers to the intent or function of the plan;
- *meaningful* and *effective* describe the consequence of experiences, in this case, the specific outcomes and impacts of informal learning experiences, which may be positive or negative, and which involve changes to or transformations in a person's cognitive, affective, psychomotor, or social domains;
- *visitors*, *learning institutions*, and *communities* describe the beneficiaries of the plan; those who derive benefit from the planning process and the plan's final recommendations.

Learning. Acquiring new or modifying existing knowledge, behaviors, skills, values, or preferences; may involve synthesizing different types of information; is often viewed as a process, rather than a collection of factual and procedural knowledge. (Compare Education.)

Literacy. The ability to identify, understand, interpret, create, communicate, compute, and use printed and written materials associated with varying contexts. Involves a continuum of learning that may enable individuals to achieve their goals, develop their knowledge and potential, and participate fully in their community and wider society (UNESCO 2004). In various fields, the concept of literacy has been expanded to include, among others, visual literacy, mathematical literacy (numeracy), scientific literacy, cultural literacy, emotional literacy, and functional literacy.

Measurement. In museum studies, the assignment of quantitative numeric units to objects or events according to rules, an operation resulting in standardized classifications of outcomes. In visitor studies or evaluation research, often refers to the effort to capture data about audiences or visitors and may include, for example, observations, interviews, focus groups, and surveys.

Objective. A statement of purpose for a project or program that is derived from a general goal stated by the museum or in a project plan and that describes the desired learner behavior and experience or content through which the behavior is to be developed; a statement of a specific, measurable, and observable result expected from an educational or interpretive activity or experience; designed to guide instructional decisions and evaluation. Often learning objectives, outcomes, and outcome statements are considered synonymous.

Outcome. In a learning context, the affective, cognitive, psychomotor, or social change or transformation in a learner that results from engagement

in a program or activity. An outcome statement is an articulation of specific, intended, direct effects on a learner in what he or she does, thinks, or feels while engaged in or as a result of an interpretive experience.

Outcome-based evaluation (OBE). The systematic measure of effect or result; employed at various intervals during and after the delivery of services, providing short- and long-term indicators of a program's effectiveness; can refer to evaluation or visitor studies that focus on concrete and measurable visitor outcomes.

Output. Measurable, observable results of a program or service that can be counted as numbers or dollars; direct products or activities measured in numeric units.

Psychomotor domain. Area of learning involved with attributes of human experience that describe behaviors, skills, actions; often used to describe one area of learning outcomes. (See also Affective domain, Cognitive domain, Social domain, Table 4.3.)

Remedial evaluation. Assessment of how all individual parts of an exhibition of interpretive project work together as a whole; often conducted in the latter stages of exhibit development or early stages of implementation in order to improve the exhibit's overall impact on visitors.

Social domain. Area of learning involved with attributes of human experience that describe engagement, discussion, and involvement with other people; sometimes used to describe one area of learning outcomes. (See also Affective domain, Cognitive domain, Psychomotor domain, Table 4.4.)

Summative evaluation. Examination of visitor experiences in an exhibition to determine various dimensions of impact and effectiveness; typically conducted after a project is completed.

Visitor. A person or group that comes in contact, in any way, with a museum or informal learning institution (e.g., personal visit, website visit); visitors may also be considered customers, guests, learners, users, or audience.

Visitor experience. All instances in which a visitor comes into contact with a museum or its collateral material (including website, advertising, programming); referred to as "moments of truth" by Carlzon (1987), who suggests that visitors make an assessment of quality immediately as they experience an institution and its collateral goods or services.

Visitor perspectives. Experiences seen from the visitor's point of view; reflects the precept that museum practitioners should hold the perspective of visitors (actual and potential) in mind as they plan, manage, and educate in informal learning settings; a goal of *visitor-centric* (also, *visitor-centered*) organizations to embrace visitors and their collective perspectives in planning and management.

Visitor studies. The discipline concerned with the study of visitors in leisure and informal educational settings; the systematic study of visitors to museums and other public educational settings and how content, design, and other features in these settings effect changes in visitors' knowledge, attitudes,

involvement level, and understanding; also, the interdisciplinary study of human experiences within informal learning settings such as museums, parks, nature centers, zoos, open lands, natural areas, and botanical gardens. Visitor studies follow rigorous research methods that adhere to the standards of the social sciences, draw from and contribute to the theory and practice of social science, and are designed to improve informal learning practice.

Wayfinding. Problem solving that visitors do to successfully find their way or follow a route and arrive at their destination, whether that be a museum, exhibit, bathroom, cafe, or the exit.

Wayshowing. Assistance that museums offer to visitors so that their wayfinding problem solving can be successful; may include maps, directional signs, written or Internet instructions, or personal help.

REFERENCES

Abercrombie, N., and B. Longhurst. 1998. *Audiences: A Sociological Theory of Performance and Imagination*. Thousand Oaks, CA: Sage Publications.

Adams, M., and J. Koke. 2008. Comprehensive Interpretive Plans: A Framework of Questions. *Journal of Museum Education* 33(3):293–99.

Ainley, M., S. Hidi, and D. Berndorff. 2002. Interest, Learning, and the Psychological Processes That Mediate Their Relationship. *Journal of Educational Psychology* 94(3):545–61.

Ajzen, I., and M. Fishbein. 1980. *Understanding Attitudes and Predicting Social Behavior*. Englewood Cliffs, NJ: Prentice-Hall.

Alexander, E.P. 1979. *Museums in Motion: An Introduction to the History and Function of Museums*. Nashville, TN: American Association for State and Local History.

American Association of Museums (AAM). 2008a. *Excellence and Equity: Education and the Public Dimension of Museums*. Washington, DC: American Association of Museums (first published 1992).

American Association of Museums (AAM). 2008b. *National Standards and Best Practices for U.S. Museums*. Washington, DC: American Association of Museums.

Anderson, D., M. Storksdieck, and M. Spock. 2007. Understanding the Long-Term Impacts of Museum Experiences. In Falk, J.H., L.D. Dierking, and S. Foust (eds.), *In Principle, In Practice*, pp. 247–60. New York: AltaMira Press.

Anderson, L.W., and D.R. Krathwohl (eds.). 2001. *A Taxonomy for Learning, Teaching, and Assessing: Revision of Bloom's Taxonomy of Educational Objectives*. New York: Longman.

Art Gallery of Ontario (AGO). 2011. Maharaja: The Splendour of India's Royal Courts. Unpublished interpretive plan. Toronto, ON.

Asimow, M. 1962. *Introduction to Design*. Englewood Cliffs, NJ: Prentice-Hall.

Bandura, A. 1986. *Social Foundations of Thought and Action: A Social Cognitive Theory*. Englewood Cliffs, NJ: Prentice-Hall.

Bartlett, F.C. 1932. *Remembering: A Study in Experimental and Social Psychology*. Cambridge: Cambridge University Press.

Bitgood, S. 2011. *Social Design in Museums: The Psychology of Visitor Studies*, Vol. 1 and 2. Edinburgh: MuseumsEtc.

Bloom, B.S. (ed.). 1956. *Taxonomy of Educational Objectives: The Classification of Educational Goals: Handbook I, Cognitive Domain*. New York: Longmans, Green.

Borun, M., and M. Chambers. 2000. Gender Roles in Science Museum Learning. *Visitor Studies Today!* 3:11–14.

Borun, M., M. Chambers, M. Dritsas, and J. Johnson. 1997. Enhancing Family Learning through Exhibits. *Curator* 40(4):279–95.

Borun, M., B. Kelly, and L. Rudy. 2011. *In Their Own Voices: Museums and Communities Changing Lives*. Philadelphia: The Franklin Institute.

Brochu, L. 2003. *Interpretive Planning: The 5-M Model for Successful Planning Projects*. Fort Collins, CO: National Association for Interpretation, InterpPress.

Brown, A. 2006. An Architecture of Value. Grantmakers in the Arts (GIA) Reader. 17(1). www.giarts.org/article/architecture-value. Accessed June 8, 2012.

Bruns, D. 1997. Benefits-Based Management: An Expanded Recreation-Tourism Management Paradigm. Presentation at the 1997 International Symposium on Human Dimensions of Natural Resource Management in the Americas. Belize City, Belize.

Bureau of Reclamation, U.S. Department of the Interior. 2002. Hoover Dam Visitor Center and Grounds Interpretive Master Plan. Unpublished interpretive plan. Boulder City, NV.

Burnham, R., and E. Kai-Kee. 2011. *Teaching in the Art Museum: Interpretation as Experience*. Los Angeles, CA: The J. Paul Getty Trust.

Butler, B.H. 1988. John Cotton Dana 1856–1929: An Introduction to the Man and His Work. *The Museologist* 51(178):1–28.

CAISE: Center for the Advancement of Informal Science Education. caise.insci.org. Accessed September 30, 2012.

Capital Regional District (CRD). 2003. *Visit, Experience, Learn: An Interpretive Plan for CRD Parks*. Victoria, BC. www.crd.bc.ca/parks/documents/interpretive_plan.pdf. Accessed October 9, 2012.

Carlzon, J. 1987. *Moments of Truth*. Pensacola, FL: Ballinger.

Chubb, M., and H.R. Chubb. 1981. *One Third of Our Time? An Introduction to Recreation Behavior and Resources*. New York: John Wiley and Sons.

Coastal Maine Botanical Gardens (CMBG). 2008. Education and Interpretive Master Plan for Coastal Maine Botanical Gardens. Unpublished interpretive plan. Boothbay, ME.

Colorado Parks and Wildlife. 2012. Staunton State Park's Community Connections Plan: A Roadmap for Interpretation, Education, Outreach and Partnerships. Unpublished master interpretive plan. Denver, CO.

Copeland, J. 2012. *Theodore Lewis Low: Visionary Director of Education at The Walters, 1946–1980*. thewalters.org/articles/entry.aspx?id = 83. Accessed September 30, 2012.

Crowley, K. 2000. Building Islands of Expertise in Everyday Family Activity: Musings on Family Learning in and out of Museums. Technical Report No. MLC-05. Pittsburg, PA: Museum Learning Collaborative.

Cummings, C.E. 1940. *East is East, West is West*. Buffalo, NY: Buffalo Museum of Science.

Czajkowski, J.W., and S.H. Hill. 2008. Transformation and Interpretation: What Is the Museum Educator's Role? *Journal of Museum Education* 33(3):255–63.

Dahlquist, D.L., J. Eells, C. Pianalto, and D. Adams. 2009. *Improving the Effectiveness of Wayshowing for America's Byways using a Visitor's Eye Perspective: Concepts and Techniques to Increase Appreciation and Action by Byway Providers*. Duluth, MN: America's Byways Resource Center.

Dana, J.C. 1917. *The New Museum. The New Museum Series #1*. Woodstock, VT: The Elm Tree Press.

Dave, R.H. 1970. Psychomotor Levels. In R.J. Armstrong, et al. *Developing and Writing Behavioral Objectives*, pp. 33–34. Tucson, AZ: Educational Innovators Press.

de Borhegyi, S.F. 1965. Testing of Audience Reaction to Museum Exhibits. *Curator* 8(1):86–93.

Detroit Institute of Arts. 2002. Revitalize, Reinterpret, Reinstall. Unpublished reinstallation project plan. Detroit, MI.

Dewey, J. 1916. *An Introduction to the Philosophy of Education*. Norwood, MA: MacMillan.

Doering, Z., and A. Pekarik. 1996. Questioning Entrance Narratives. *Journal of Museum Education* 21(3):20–23.

Driver, B.L. 1996. Benefits-Driven Management of Natural Areas. *Natural Areas Journal* 16(2):94–99.

Falk, J.H. 2009. *Identity and the Museum Visitor Experience*. Walnut Creek, CA: Left Coast Press, Inc.

Falk, J.H., and L.D. Dierking. 2000. *Learning from Museums: Visitor Experience and the Making of Meaning*. Walnut Creek, CA: AltaMira Press.

Falk, J.H., and L.D. Dierking. 2010. The 95% Solution: School Is Not Where Most Americans Learn Most of Their Science. *American Scientist* 98:468–93.

Falk, J.H., T. Moussouri, and D. Coulson. 1998. The Effect of Visitors' Agendas on Museum Learning. *Curator* 21(2):106–20.

Fischer, D. 1996. Visitor Panels: In-house Evaluation of Exhibit Interpretation. *Visitor Studies: Theory, Research, and Practice* 9:51–62.

Fischer, D. 1997. Connecting with Visitor Panels. *Museum News* May/June:33–37.

Friedman, A. (ed.). 2008. *Framework for Evaluating Impacts of Informal Science Education Projects*. http://caise.insci.org/uploads/docs/Eval_Framework.pdf. Accessed October 9, 2012.

Gadamer, H-G. 1975. *Philosophical Hermeneutics*. Ed. and transl. David Linge. Berkeley: University of California Press.

Gardner, H. 1993. *Frames of Mind: The Theory of Multiple Intelligences* (2nd ed.). New York: Basic Books.

Goode, G.B. 1889. In *The Museums of the Future: Report of the National Museum. 1888–1889*, pp. 427–45. Washington, DC: Government Printing Office.

Government Performance and Results Act of 1993 (GPRA), Public Law no. 103–62.

Haas, G.E., M.D. Wells, V. Lovejoy, and D. Welch. 2007. *Estimating Future Recreation Demand: A Decision Guide for the Practitioner*. Denver, CO: U.S. Department of the Interior, Bureau of Reclamation, Office of Program and Policy Services, Denver Federal Center.

Hakala, J.S.H. 2008. Building Balance: Integrating Interpretive Planning in a Research Institution. *Journal of Museum Education* 33(3):273–76.

Hatry, H., T. van Houten, M.C. Plantz, and M. Taylor Greenway. 1996. *Measuring Program Outcomes: A Practical Approach*. Alexandria, VA: United Way of America, Task Force on Impact.

Hein, G. 1995. The Constructivist Museum. *Journal of Education in Museums* 16:21–23.

Hein, G. 1998. *Learning in the Museum*. London: Routledge.

Hein, G. 2012. *Progressive Museum Practice: John Dewey and Democracy*. Walnut Creek, CA: Left Coast Press, Inc.

Hirsch, E.D. 1996. *The Schools We Need: And Why We Don't Have Them*. New York: Doubleday.

Hooper-Greenhill, E. 2007. *Museums and Education: Purpose, Pedagogy, Performance*. New York: Routledge.

Institute of Museum and Library Services. 2000. *Perspectives on Outcome Based Evaluation for Libraries and Museums.* www.imls.gov/assets/1/AssetManager/PerspectivesOBE.pdf. Accessed September 30, 2012.

Institute of Museum and Library Services. 2006. *Shaping Outcomes.* www.shaping-outcomes.org. Accessed October 9, 2012.

Iyengar, S. 2007. *How the U.S. Funds the Arts.* Washington, DC: National Endowment for the Arts, Office of Research & Analysis.

Jackson, M.R. 2008. *Progress in Arts and Culture Research: A Perspective.* Washington, DC: The Urban Institute. www.urban.org/UploadedPDF/411806_arts_and_culture.pdf. Accessed June 14, 2012.

Jackson, M.R., F. Kabawasa-Green, and J. Herranz, 2006. *Cultural Vitality in Communities: Interpretation and Indicators.* Washington, DC: The Urban Institute. www.urban.org/uploadedpdf/311392_Cultural_Vitality.pdf. Accessed June 14, 2012.

Johnson, P., and B. Thomas. 1998. The Economics of Museums: A Research Perspective. *Journal of Cultural Economics* 22(2–3):75–85.

Kania, J., and M. Kramer. 2011. Collective Impact. *Stanford Social Innovation Review* 43. www.ssireview.org/articles/entry/collective_impact. Accessed June 8, 2012.

Katz, P.M. 2010. *Service Despite Stress: Museum Attendance and Funding in a Year of Recession: A Report from the American Association of Museums.* Washington, DC: American Association of Museums.

KnowledgeWorks. 2008. *2020 Forecast: Creating the Future of Learning.* Palo Alto, CA: Institute for the Future.

Knowles, M.S. 1973. *The Adult Learner: A Neglected Species.* Houston, TX: Gulf Publishing.

Knowles, M.S. et al. 1984. *Andragogy in Action: Applying Modern Principles of Adult Education.* San Francisco, CA: Jossey-Bass.

Koke, J. 2008. Comprehensive Interpretive Plans: The Next Step in Visitor Centeredness and Business Success? *Journal of Museum Education* 33(3):247–54.

Koke, J., and M. Adams (eds.). 2008. Institution Wide Interpretive Planning. Museum Education Roundtable. *Journal of Museum Education* 33(3):233–307.

Kolb, D.A. 1984. *Experiential Learning: Experience at the Source of Learning and Development.* Englewood Cliffs, NJ: Prentice Hall.

Korn, R. 2008. Transforming Museums—To What End? Published in Proceedings for Transforming Museums Conference. Seattle, WA.

Kort, B., R. Reilly, and R.W. Picard. 2001. An Affective Model of Interplay Between Emotions and Learning: Reengineering Educational Pedagogy-Building a Learning Companion. In *Proceedings of the IEEE International Conference on Advanced Learning Technologies.* Madison, WI: IEEE.

Kozoll, R., and M. Osborne. 2004. Finding Meaning in Science: Lifeworld, Identity and Self. *Science Education* 88(2):157–81.

Krathwohl, D.R., B.S. Bloom, and B.B. Masia. 1964. *Taxonomy of Educational Objectives: The Classification of Educational Goals. Handbook II: Affective Domain.* New York: David McKay.

Kratz, S., and E. Merritt. 2011. Museums and the Future of Education. *On the Horizon* 19(3):188–95.

Leinhardt, G., and K. Knutson. 2004. *Listening in on Museum Conversations.* Walnut Creek, CA: AltaMira Press.

Leinhardt, G., K. Crowley, and K. Knutson (eds.). 2002. *Learning Conversations in Museums.* London: Psychology Press, Taylor & Francis.

Low, T. 1942. *The Museum as a Social Instrument*. New York: The Metropolitan Museum of Art.

Management Multiple Use and Sustained Yield Act of 1964. Public Law no. 86–517. June 12, 1960, amended December 31, 1996 (Public Law no. 104–333).

Manjarrez, C. et al. 2008. *Exhibiting Public Value: Government Funding for Museums in the United States*. Washington, DC: Institute of Museum and Library Services. www.imls.gov/assets/1/AssetManager/MuseumPublicFinance.pdf. Accessed October 9, 2012.

Maurer, E. 2008. From the Editor. *Journal of Museum Education* 33(3):233.

McLean, K. 1993. *Planning for People in Museum Exhibitions*. Washington, DC: Association of Science-Technology Centers.

Merritt, E., and V. Garvin. 2007. *Secrets of Institutional Planning*. Washington, DC: American Association of Museums.

Meszaros, Cheryl. 2008. Un/Familiar. *Journal of Museum Education* 33(3):239–46.

Myers, O.E., C.D. Saunders, and A.A. Birjulin. 2004. Emotional Dimensions of Watching Zoo Animals: An Experience Sampling Study Building on Insights from Psychology. *Curator* 47(3):299–321.

National Association for Interpretation, 2007. www.definitionsproject.com/definitions. Accessed October 5, 2012.

National Environmental Education and Training Foundation. 1998. *The National Report Card on Environmental Knowledge, Attitudes and Behaviors: Seventh Annual Survey of Adult Americans*. Washington, DC: Roper Starch Worldwide.

National Environmental Policy Act of 1969. Public Law no. 91–190. 42 U.S.C. 4321–61.

National Park Service (NPS). 1983. *Interpretive Planning Handbook*. Harpers Ferry, WV: National Park Service, Harpers Ferry Center.

National Park Service (NPS). 1988. *The Interpretive Challenge*. Washington, DC: U.S. Department of the Interior, National Park Service.

National Park Service (NPS). 1996. *Interpretive Planning: Interpretation and Visitor Services Guideline, NPS-6, Chapter III*. Washington, DC: U.S. Department of the Interior, National Park Service.

National Research Council. 2009. *Learning Science in Informal Environments: People, Places, and Pursuits*. Committee on Learning Science in Informal Environments, P. Bell, B. Lewenstein, A.W. Shouse, and M.A. Feder (eds.). Board on Science Education, Center for Education, Division of Behavioral and Social Sciences and Education. Washington, DC: The National Academies Press.

Newman, K., and P. Tourle. 2011. *The Impact of Cuts on UK Museums: A Report for the Museums Association*. www.museumsassociation.org/download?id = 363804. Accessed October 9, 2012.

Patton, M.Q. 1997. *Utilization-Focused Evaluation: The New Century Text* (3rd ed.). Thousand Oaks, CA: Sage Publications.

Peart, B., and J.G. Woods. 1976. A Communication Model as a Framework for Interpretive Planning. *Interpretation Canada* 3(5):22–25.

Pekarik, A.J. 2010. From Knowing to Not Knowing: Moving Beyond "Outcomes." *Curator* 53 (1):105–15.

Perry, D.L. 1993. Designing Exhibits that Motivate. In M. Borun, S. Grinell, P. McNamara, and B. Serrell (eds.), *What Research Says about Learning in Science Museums*, vol. 2, pp. 25–29. Washington, DC: Association of Science-Technology Centers.

Perry, D.L. 2012. *What Makes Learning Fun? Principles for the Design of Intrinsically Motivating Museum Exhibits*. New York: AltaMira Press.

Piaget, J. 1936. *Origins of Intelligence in the Child.* London: Routledge and Kegan Paul.

Piaget, J. 1969. *Science of Education and the Psychology of the Child.* Ed. and transl. D. Coltman. New York, NY: Viking Press.

Pond, K.L. 1993. *The Professional Guide: Dynamics of Tour Guiding.* New York: Van Norstrand Reinhold.

Roberts, L. 1991. The Elusive Qualities of "Affect." *ILVS Review* 2(1):133–36.

Robinson, E.S. 1928. *The Behavior of the Museum Visitor.* Washington, DC: American Association of Museums, New Series, #5.

Robinson, Sir K. 2008. Changing Paradigms: How We Implement Sustainable Change in Education. RSA/Edge Lecture presented June 16, 2008, London, RSA (Royal Society for the Encouragement of Arts, Manufactures and Commerce).

Royal British Columbia Museum (RBCM). 2008. RBCM Visitor Experience Master Plan: A Vision for the Visitor Experience. Unpublished project report. Victoria, BC.

Schor, J.B. 1991. *The Overworked American: The Unexpected Decline of Leisure.* New York: Basic Books.

Scott, C. 2006. Museums: Impacts and Value. *Cultural Trends* 15(1):45–75.

Scott, C. 2009. Exploring the Evidence Base for Museums Value. *Museums Management and Curatorship* 24(3):195–212.

Screven, C.G. (ed.). 1999. *Visitor Studies Bibliography and Abstracts* (4th ed.). Chicago: Screven and Associates.

Serrell, B. 1996. *Exhibit Labels: An Interpretive Approach.* Walnut Creek, CA: AltaMira Press.

Serrell, B. 1998. *Paying Attention: Visitors and Museum Exhibitions.* Washington, DC: American Association of Museums.

Sheppard, B. 2000. Introduction in *Perspectives on Outcome Based Evaluation for Libraries and Museums,* pp. 2–3. Washington DC: Institute of Museum and Library Services. www.imls.gov/assets/1/workflow_staging/AssetManager/214.PDF. Accessed October 9, 2012.

Shettel, H.H. 2008. No Visitor Left Behind. *Curator* 51(4):367–75.

Silverman, L. 1995. Visitor Meaning-Making for Museums in a New Age. *Curator* 38(3):161–70.

Sobel, D. 1995. *Beyond Ecophobia: Reclaiming the Heart of Nature Education.* Great Barrington, MA: The Orion Society and the Myrin Institute.

Summers, M. 1999. Defining Literary Upward. *Forbes* 164:70–72.

Swift, F. 2002. Briefing Paper: Developing an Interpretive Strategy. London: Museums and Galleries Commission.

Tilden, F. 1957. *Interpreting Our Heritage.* Chapel Hill: University of North Carolina Press.

Timberlake, S.A. 1999. The Effect of the Government Performance and Results Act on Museums. *Visitor Studies Today!* 2(2):8–10.

Trautmann, C. 2011. "Nice to Necessary: The Path to Significance and Support for Science Centers." *The Informal Learning Review* No. 111:2–6.

United Nations Educational, Scientific and Cultural Organization (UNESCO). 2004. *The Plurality of Literacy and its Implications for Policies and Programs. Education Sector Position Paper #13.* unesdoc.unesco.org/images/0013/001362/136246e.pdf. Accessed October 9, 2012.

United States Department of Education. 2011. An Overview of School Turnaround. Technical Assistance Presentation. www2.ed.gov/programs/sif/sigoverviewppt.pdf. Accessed October 9, 2012.

Veverka, J.A. 1994. *Interpretive Master Planning: The Essential Planning Guide for Interpretive Centers, Parks, Self-Guided Trails, Historic Sites, Zoos, Exhibits and Programs.* Tustin, CA: Acorn Naturalists.

Veverka, J.A. 2011. *Interpretive Master Planning* (2 vols.). Edinburg: Museums Etc.

Vygotsky, L.S. 1978. *Mind in Society: The Development of Higher Psychological Processes.* Cambridge, MA: Harvard University Press.

Walking Mountains Science Center. 2010. Interpretive Plan and Concept Design. Unpublished interpretive plan. Avon, CO.

Webb, R.C. 1996. Comparing High-Involved and Low-Involved Visitors: A Review of the Consumer Behavior Literature. *Visitors Studies: Theory, Research and Practice* 9:276–87.

Weil, S.E. 1990. *Rethinking the Museum: An Emerging New Paradigm.* Washington, DC: Smithsonian Institution Press.

Weil, S.E. 1997. *Outcome-Based Evaluations, In My Opinion.* Washington, DC: National Center for Non-Profit Boards.

Weil, S.E. 2000. Transformed from a Cemetery of Bric-a-brac In *Perspectives on Outcome Based Evaluation for Libraries and Museums,* pp. 4–15. Washington, DC: Institute of Museum and Library Services.

Weil, S.E. 2002. *Making Museums Matter.* Washington, DC: Smithsonian Institution Press.

Weil, S.E. 2003. Beyond Big and Awesome: Outcome-Based Evaluation. *Museum News* Nov/Dec:40–53.

Wells, M. 2006. Audience Analysis for Awbury Arboretum. Unpublished report to the Awbury Arboretum. Philadelphia, PA.

Wells, M. 2008. An Evaluation of the Effectiveness of National Park Service Interpretive Planning. *Journal of Museum Education* 33(3):283–91.

Wells, M., and B. Butler. 2002. A Visitor-Centered Evaluation Hierarchy. *Visitor Studies Today!* 5(1):5–11.

Wells, M., and B. Butler. 2004. A Visitor-Centered Evaluation Hierarchy: Helpful Hints for Understanding the Effects of Botanical Garden Programs. *The Public Garden* 19(2):11–13.

Wells, M., and R. Loomis. 1998. A Taxonomy of Museum Program Opportunities: Adapting a Model of Natural Resource Management. *Curator* 41(4):254–64.

Wells, M., and L. Smith. 2000. *The Effectiveness of Nonpersonal Media Used in Interpretation and Informal Education: An Annotated Bibliography.* Fort Collins, CO: National Association for Interpretation.

Wilderness Act of 1964. Public Law no. 88–577. 16 U.S.C. 1131–1136. September 3, 1964.

W.K. Kellogg Foundation. 1998. *W.K. Kellogg Foundation Evaluation Handbook.* www.wkkf.org/knowledge-center/resources/2010/W-K-Kellogg-Foundation-Evaluation-Handbook.aspx. Accessed October 9, 2012.

Yucco, V., J. Heimlich, E. Meyer, and P. Edwards. 2009. Measuring Public Value: An Instrument and an Art Museum Case Study. *Visitor Studies* 12(2):152–63.

Worts, D. 2010. Culture and Museums in the Winds of Change. In G. Anderson (ed.), *Reinventing the Museum: The Evolving Conversation on the Paradigm Shift* (2nd ed.), pp. 250–66. Plymouth, UK: AltaMira Press.

Index

5-M model, 35

About the Authors

Marcella Wells, PhD, is president of Wells Resources, Inc., a woman-owned small business that specializes in interpretive planning, visitor studies, and project management. Founded in 2000, Wells Resources works with federal, state, and local land management agencies, informal learning settings (e.g., museums, parks, nature centers), and non-profit organizations as a visitor advocate. Before founding the company, Marcella was a faculty member of Colorado State University where she mentored graduate students and taught courses in interpretation, interpretive planning, environmental education, and leisure studies. She is past vice president of the Visitors Studies Association, current member of the American Alliance of Museums education committee (EdCom), and steering committee member for the Children and Nature Connection in Fort Collins, Colorado. In 2012, Marcella was awarded the Enos Mills Lifetime Achievement Award by the Colorado Alliance for Environmental Education.

Barbara Butler, PhD, is enjoying her life of retirement in the village of Placitas, New Mexico, after a challenging and varied career that included being a professor of anthropology and museum studies and serving as director of a natural history museum, and culminated in holding various positions in the Informal Science Education program at the National Science Foundation (NSF). This opportunity fused her anthropological perspective with her interest in informal learning, which was originally sparked in her first job as a science educator at the Buffalo Museum of Science. While at NSF she learned of the Visitor Studies Association (VSA), which offered opportunities to pursue her interests in understanding more about the museum visitor and informal learning. She served two terms on the VSA board and was chair of the VSA professional development committee.

Judith Koke is Director of Education and Interpretive Programs at the Nelson-Atkins Museum of Art in Kansas City, Missouri. Previously, Judy has been Deputy Director of Education and Public Programming at the Art Gallery of Ontario, a senior researcher at the Institute for

Learning Innovation in Annapolis, Maryland, and Deputy Director of the University of Colorado Museum of Natural History. In each of these roles, she has led cultural change to support data-driven, visitor-centered practice. Judy has been an adjunct professor or instructor in graduate museology programs at the University of Toronto, George Washington University, and the University of Colorado. She served for seven years as manager of visitor studies and evaluation at the Denver Museum of Nature and Science.